The 5-Mile Thoughts Annual
Volume One

By
James E. Cameron

Table Of Contents

Introduction From The Author

They say you should write what you know. Well, lucky for all of you, I know a lot. Too much, really. And since this cursed existence demands some outlet for my ceaseless observations and disdain, I've chosen to grace the internet with my insights. Specifically, on Substack.com—because, let's face it, if you want to shout into the void and be barely heard above the cacophony of mediocrity, that's the place to do it.

Enter "5-Mile Thoughts," a sprawling, unapologetic exploration of everything that matters (and much that doesn't). From the cosmic joke that is existence itself to the never-ending clown show of current events, to historical tid-bits dredged up from humanity's ever-baffling past—nothing is sacred, and everything is fair game.

My goal? Simple. To educate, entertain, and thoroughly piss off anyone reckless enough to stumble across this repository of refined cynicism. Whether you're here for enlightenment or just to gnash your teeth in impotent rage, welcome. You'll get both.

Cynically Yours,
James E. Cameron
2025

On the Question of Humanity's Origins

Stop flipping the coin and look outside the box

On the Question of Humanity's Origins

Stop flipping the coin and look outside the box

When worlds collide, it hurts.

I have always harboured a mind that refuses to settle for the trite explanations spoon-fed to the masses. I question every fragment of our existence and the societal orthodoxies that have been erected like mindless statues, unquestioned by most. Among these hollow idols, perhaps the most laughable is the orthodoxy surrounding humanity's origins.

It's a mainstream belief that humanity can be understood through the tired, binary frameworks of creationism or evolution, two systems that, for all their posturing, rely on dogmas dressed up as science or spirituality. Creationists, with their ancient texts, cling to notions that might as well be campfire tales. Meanwhile, the evolutionists drape themselves in the garb of "objectivity" and "science," yet still worship at the altar of scientism—an unspoken religion cloaked in the language of enlightenment but born out of the rigid, unforgiving absolutism of Victorian Christian thought. They tell us evolution is sacred truth, yet at its core, it's little more than a cold, clinical myth built on the bones of unquestioned faith.

Let me be clear: I don't align with either side of this debate. My view is based on empirical observation, but I know well that it'll be greeted with the usual cries of heresy from all corners. And yet, here's my take—the inconvenient truth I suspect neither camp can bear to entertain: we are not, as they claim, a single, unified species. Instead, we are a collection of subspecies, divided by biology and nature as surely as any other species on Earth.

I'll pause here, give them a moment to exhaust themselves with the usual accusations, every tired "-ism" they can muster. Done? Good. Let's move on to the gritty truth.

Let's start by addressing the camp that collapses under the simplest application of logic and myth-busting: Creationism. According to this perspective, an omnipotent being allegedly designed and sparked into existence... well, existence itself. This brings up the rather glaring question: if there was truly nothing before, where exactly was God? Where did God come from? But let's save that philosophical can of worms for another day. For now, let's dissect the claims Creationism puts

forward by going straight to its "source," that most over-cited piece of religious fan-fiction, the Bible.

One of the most commonly quoted verses goes something like this:

"...And God said, Let us make man in our image, after our likeness...So God created man in his own image, in the image of God created he him; male and female created he them."

Already, we have a celestial editorial team that can't keep track of who "us" refers to in a supposedly monotheistic framework. But let's humour the premise for a moment—until we reach the very next chapter, where we stumble into a blatant continuity error worthy of a third-rate writer's room:

"And the Lord God caused a deep sleep to fall upon Adam, and he slept: and he took one of his ribs, and closed up the flesh instead thereof; And the rib, which the Lord God had taken from man, made he a woman, and brought her unto the man."

Now, apparently, the first draft of humanity was unsatisfactory to our great "sky-daddy," so he tries again and stumbles into what looks suspiciously like an experiment in cloning.

Then, we have Adam and Eve's children, Cain and Abel. Cain, in a fit of jealousy, kills Abel, gets marked, and wanders off to the land of Nod—where, inexplicably, he finds a wife. That's right: in a world supposedly populated by a grand total of three humans, Cain somehow discovers a spouse. Then Cain starts begetting children of his own, without so much as a footnote explaining where all these other people came from.

The narrative stumbles along with Seth, another son, who also starts begetting the entire human race. Who's he begetting with? Well, the story is conveniently silent on that, leaving us to assume either some cosmic recycling or a profoundly awkward family situation. Eventually, we reach Chapter 5, where yet another "soft reboot" takes place, abandoning any pretence of consistency. No women are named; they're merely anonymous accessories to the "begetting."

In short, the Christian creation myth as written is an editorial disaster—a chaotic mess that reads like it was slapped together in one draft, never proofread, and then defended at all costs. It's utterly absurd that anyone would cling to this as a "factual" account.

Now, let's flip the coin and take a look at what the "cult of science" has to say.

Anthropology has made strides—though perhaps strides is too optimistic a word for the chaotic scrabble that brought humanity to this point. A casual glance at its Wikipedia entry, surprisingly, supports some of my less charitable theories on the matter:

"Human evolution is the evolutionary process within the history of primates that led to the emergence of Homo sapiens as a distinct species of the hominid family that includes all the great apes. This process involved the gradual development of traits such as human bipedalism, dexterity, and complex language, as well as interbreeding with other hominins (a tribe of the African hominid subfamily), indicating that human evolution was not linear but web-like."

Web-like? The term alone presumes an underlying order, a delicate symmetry—rather than the ravenous, bristling thicket that humanity has mutated into, strangling the diversity of life beneath its unchecked growth. But then, biology's tendency to romanticize its subject is almost as relentless as nature itself.

Yet even this mild concession to the unpredictable is quickly betrayed by the "cult of science" and its insistence on a neatly packaged narrative of origins:

"According to the recent African origin theory, modern humans evolved in Africa possibly from H. heidelbergensis, H. rhodesiensis or H. antecessor and migrated out of the continent some 50,000 to 100,000 years ago, gradually replacing local populations of H. erectus."

This is the pivot point, the ideological keystone of the entire argument: humanity as a single-source contagion, emanating from a single place—a 'version 1.0' of sorts, that spread across the world with the unchecked and metastatic zeal of a cancer.

And here is where the "coping" begins, a remarkable exercise in cognitive dissonance. The tale must twist and warp to suit the comforting fantasy of a linear progression, sidestepping the awkward messiness of hybridizations, regional developments, and evolutionary dead-ends that litter our past. It must fuse and consume these inconvenient truths, all to uphold the fantasy of humanity as some kind of destined, unified pinnacle of evolution—a narrative equal parts hubris and selective memory.

8

Imagine, for a moment, that instead of a single strain—the mythical, solitary lineage of humanity—we were actually looking at multiple, parallel evolutionary paths, each a unique response to the myriad demands of survival across diverse environments. This is not some far-fetched fantasy; in fact, it's suggested even in the mainstream narrative—until, of course, this inconvenient multiplicity is "wiped out" by the comforting fiction of a single origin. The tale then shifts to uphold the "weaker, smaller" strain, the one that eventually congealed into what we know as humanity's unwashed masses.

This notion of converging origins is hardly foreign to nature. Yet we watch science, with its smug facade, cling to a narrative of simple succession. And at the core of this mythos lies Darwin's plagiarized evolutionary theory, the holy scripture of this so-called cult of science. For all the reverence showered upon Darwin's work, it is not even his original words that are enshrined but rather a redacted version propagated by the high priests of scientific orthodoxy. On the Origin of Species, formally titled On the Origin of Species by Means of Natural Selection, or the Preservation of Favoured Races in the Struggle for Life, remains readily available, still in print, yet largely unread in its raw, unfiltered form. Instead, what reigns supreme are the interpretations handed down by science's self-appointed arbiters, their op-eds and dogmas reshaping the source text into a doctrinal cudgel.

In this light, the resemblance between organized religion and mainstream science becomes glaring. Both are systems built around carefully curated dogma, enforced by their priestly class who decide what the faithful should believe. Neither encourages critical examination or genuine inquiry; rather, both are driven by blind observance. Challenges to the orthodoxy are heresy, met with scorn, suppression, or dismissal. Both paths demand obedience to second-hand opinions, to interpretations crafted and re-crafted to maintain a veneer of stability. Just as religious institutions suppress heterodox views to protect their followers from "dangerous" ideas, so too does science sanitize the chaos of human evolution into a palatable tale for its adherents.

It is a shared story of selective memory and relentless self-preservation —whether draped in robes or lab coats, the result is the same: a congregation too cowed to look directly at the source, their voices quelled, their curiosity neutered.

My theory, grounded firmly in recorded evidence, is both straightforward and far more credible than the sanitized "Out of Africa" fairy tale spoon-

fed to the masses. Humanity's origins are, in fact, a mosaic of subspecies, each following a distinct, parallel evolutionary path rather than a tidy, single-source lineage. This view doesn't merely challenge the mainstream narrative; it shatters it outright.

Forget the "lies to children" notion of humanity's emergence from one pure, linear strain. In reality, multiple hominin populations across different regions developed unique traits suited to their environments, adapting in ways that had nothing to do with some mythical, unified source. Over time, these groups interbred, hybridizing in a manner that explains the genetic complexity of "Homo sapiens" today. The neat, sanitized model of a one-size-fits-all lineage is pure fantasy—a narrative that crumbles in the face of actual evidence.

The fossil and genetic record doesn't support a single, unbroken human line; it points to a web of branches, to populations that evolved separately and merged at various points, creating something far richer and messier than the simple-minded tale of "one human family." But simplicity, of course, is what science sells, dismissing the thornier, more chaotic truths that don't fit its narrow script.

The fossil record, in all its raw and inconvenient glory, reveals a vast and tangled spectrum of hominin species: Neanderthals, Denisovans, and lesser-known groups like Homo floresiensis and Homo naledi. These were not "failed experiments" or inferior prototypes discarded by evolution but robust, adaptive populations that thrived in their own rights. Modern genetics drives this point home with force, revealing traces of Neanderthal and Denisovan DNA persisting within our very genes. This reality challenges the simplistic notion that these groups were mere evolutionary "dead ends," discarded to clear the path for some supposed "pinnacle" of Homo sapiens.

Yet mainstream science clings to its single-origin myth like a security blanket, desperately preserving the comforting idea of a unified, superior human "race." It's a story built for the masses, one that overlooks inconvenient data and the research of scholars like Alan Templeton and Chris Stringer, who offer a more nuanced and complex model—one that recognizes our origins as fractured, diverse, and anything but linear.

In stubbornly defending this watered-down version of human evolution, modern science mirrors the most stifling forms of religious orthodoxy. It disregards alternative perspectives as pseudoscience and buries evidence that doesn't fit the script, all to protect its cherished fable of human exceptionalism.

The narrative we're fed isn't about truth, nor is it about scientific rigour; it's about controlling the story of human identity, shaping it into something tidy, flattering, and utterly false. The real story of humanity's origins is messy, fragmented, and humbling—a web of failed hybrids, dead-ends, and hybridizations that produced what we are today. In reality, we are just another species, another animal with enough hubris to believe we're somehow above it all. Science, in its zeal to tell us otherwise, has simply built another altar to human arrogance.

The Beginning of All Things

Big Energy

The Beginning of All Things
Big Energy

There is something almost uniquely maddening about the eternal back-and-forth over the origins of the universe, especially when framed as if it's the pivotal mystery of existence. It's a debate as old as time and yet, inexplicably, still manages to wriggle its way into conversations, lingering like a bad smell from one era to the next. It's as though people are still clutching at answers to life's grand questions without realizing that, by now, everyone's lost interest.

In Britain, perhaps the collective eye-roll at religious explanations has become a national pastime, and it's not hard to see why. Consider the Biblical account:

"In the beginning, God created the heaven and the earth. And the earth was without form, and void; and darkness was upon the face of the deep. And the Spirit of God moved upon the face of the waters. And God said, Let there be light: and there was light. And God saw the light, that it was good: and God divided the light from the darkness."

Cue the sigh of incredulity.

Now, let's pause for a moment and actually consider the supposed sequence here. The deity who "created" everything—from light to life—supposedly came from...nothing? How exactly did this "God" manage to exist in a pre-universe limbo, waiting for the cue to create everything? And if there's no answer to that, what's the point of the whole exercise? It's a plot-hole so glaringly absurd that it would be tossed out of any halfway decent novel draft. Yet, here it stands, still taken seriously by the faithful as if scientific evidence and reason aren't waiting patiently just a few steps away, offering a more plausible narrative.

Despite the mounds of evidence suggesting that our universe is billions of years old, some die-hard creationists will cling to the idea that it's all only a few thousand years old, because that's what their holy book says. The cognitive gymnastics here are astounding. The moment you introduce just a smidgen of scientific scrutiny—radioactive decay, the speed of light, even basic geology—the entire timeline of creationism crumbles like a badly constructed sandcastle.

NEXT!!!

The scientific orthodoxy, or what I like to call the Cult of Big Bang, has all the poetic finesse of a toaster manual. And it's gloriously summed up by Terry Pratchett in Lords and Ladies:

"In the beginning, there was nothing, which exploded."

That's it in a nutshell, folks. The great cosmic firecracker that allegedly set off everything, according to our supposed intellectual betters. It's the official gospel of cosmology, complete with its own faithful who would sooner question their own existence than poke holes in the dogma of the Big Bang. But, as we all know, no journey into this wilderness of sanitized misinformation would be complete without stopping off at Wikipedia—a bastion of facts that are as reliable as a horoscope in the back of a tabloid. Here's how Wikipedia sums it up:

"The Big Bang is a physical theory that describes how the universe expanded from an initial state of high density and temperature. The notion of an expanding universe was first scientifically originated by physicist Alexander Friedmann in 1922 with the mathematical derivation of the Friedmann equations."

Ah, the Friedmann equations—so abstract that they might as well be arcane spells, peddled as if they bring us closer to enlightenment. But let's step back a moment and consider the delicious absurdity here. Basic mathematics tells us that zero is nothing: a null state, a void. You can dress it up in as many equations as you like, but as Eric Idle succinctly sang, "You know, you come from nothing, you're going back to nothing. What have you lost? Nothing." Zero multiplied, divided, or jazzed up with Greek letters still equals zero. So, please, enlighten me—how exactly does one "calculate" the start of everything from nothing?

And then there's the whole matter of spatial logistics. If every last ounce of energy and mass in the universe was squashed down into one infinitesimal point, then where exactly was this all-powerful little speck located? Even if you manage to choke down the "everything from nothing" spiel, it still begs the question of where all this "high density and temperature" could exist.

Oh, I hear the scoffing already—"So, genius, what's your grand theory?" Well, brace yourselves, because this one requires a little more intellectual dexterity than your usual spoon-fed doctrines.

Let's start with the obvious: the universe is not a "thing." It's not a giant sandbox of atoms bumping around in a cosmic snow globe. It's a vast, boundless energy field—an endless sea of frequencies, one of which happens to be the mundane sliver of reality we occupy. Wrap your minds around that for a moment. Still with me? Good. Let's press on.

Our so-called "material universe" is simply one particular frequency of energy, bound by what we recognize as the speed of light. Think of it like software on a computer: the universe is the code, ticking along with a processing limit—the speed of light is its clock speed. The hardware can only chug along at this pre-set rate, interpreting reality within these constraints. Yes, if you must know, this does lead us into Matrix territory, but bear with me because it also gives a neat answer to the vexing question: What came before everything?

Energy, that irrefutable cornerstone of physics, cannot be created or destroyed, only shifted around and transformed. Now, what if our universe is just the sluggish, dense end of a cosmic recycling system? Its energy, at a ploddingly low frequency, drags along in slow motion, bound by our familiar laws of matter and time. But look beyond—at higher frequencies, energy exists in faster, more fluid states. Ours is the cosmic equivalent of dial-up internet; elsewhere, perhaps, is fiber-optic.

This idea—grasp it, if you can—suggests that the universe didn't "begin" as much as it endlessly loops through cycles of decay and renewal, each iteration borrowed from and shaped by higher energies, swirling above our limited perception. But do mainstream scientists pay any mind to this? Not a chance. They're too wrapped up in proving and re-proving their tidy Big Bang narrative, even as the unanswered questions pile up. Meanwhile, this concept, which could truly be the holy grail they're all scrambling for, goes unexplored.

15

On Kemi Badenoch

Conservatives try to out left the Left

On Kemi Badenoch

Conservatives try to out left the Left

Ah, yes, Britain's Conservative Party has crowned yet another leader, and I'm late to the chorus of raised eyebrows and muted groans, watching the country's political circus run its usual routine of self-sabotage.

We've got Kemi Badenoch at the helm now—a choice that, even in a political landscape made numb by mediocrity, manages to bring fresh levels of incredulity. What the establishment sees as a stroke of brilliance —propping up a "diverse" leader—is in reality the most transparent of DEI pandering, thinly disguised as bold decision-making. Look, folks, a Nigerian leader! Proof positive that the Tories have no problem filling diversity quotas, while continuing to lack any vestige of true ideological backbone. You'd think the optics were everything, given how deeply these decisions are shaped by the relentless tides of leftist media scorn.

But what does it matter who's steering the ship, when the course is set for ideological shipwreck anyway? The entire political spectrum has slid left, hollowing out true conservatism and transforming it into a shadow of its former self. Policies that once sat squarely in the middle are now slandered as hard-right, as Britain's political movers march proudly into progressive quicksand. It started decades ago, really, back when "New Labour" set about dismantling every last remnant of genuine working-class representation, killing off organized labour with a grin as big corporations and NGOs started calling the shots. Blair may have left a trail of ruin in Iraq, but the real damage he inflicted was at home, where his administration helped institutionalise corporatised, sanitised politics— a beast whose claws still choke the pulse of our supposedly sovereign nation.

Now, it's laughably obvious that our government and even our constitutional monarchy itself operate like departments of the World Economic Forum. We're ruled not by votes or values, but by whatever flavour of internationalist, corporatist agenda is ladled out at the latest Davos gathering. At present, both our Prime Minister and Monarch are linked up with the WEF, in case anyone still believes there's a semblance of impartial governance left.

And as Badenoch's unlikely ascendancy gives the Conservatives a passing moment of smug self-congratulation, one can only watch as the Reform Party remains blissfully idle, convinced the Tories will collapse

under the weight of their own hypocrisy. How nice it would be to have someone—anyone—with a spine to shake things up, but let's not expect courage from Reform, who are too busy running around in circles on the so-called "right." If only Robert Jenrick had managed to snag the leadership spot; perhaps he could have roused Nigel Farage from his slumber and reminded him that Britain still desperately needs an unapologetic conservative voice.

Meanwhile, the farcical spectacle of "left-wing" ideology—now so completely untethered from reality it's practically orbiting Pluto—has twisted public perception beyond repair. Formerly centrist ideas are now condemned as "extreme," and anyone suggesting that governance should put the welfare of its citizens first is branded as backward or bigoted. How far we've fallen, where politicians are more terrified of offending Twitter mobs than addressing the nation's needs.

It's well past time for genuine conservatives to reclaim the stage and stop kowtowing to the ever-more-ridiculous whims of political correctness. Embrace the labels, wear them with pride, and let's call out this emperor without clothes. We're here for governance that defends our people, stands against chaos at home and abroad, and doesn't buckle at every bleating outrage from the latest fringe fad. Britain deserves better than these pretenders and apologists who pander to foreign interests and corporate overlords while abandoning the working class to fend for itself.

Labour Hides in the Shadows

Farmers scare the living s**t out of the Parlimentary Labour Party...And with good reason

OBLIVIONMEDIA.SUBSTACK.COM

Labour Hides in the Shadows

*Farmers scare the living s**t out of the Parlimentary Labour Party...And with good reason*

Sir Keir Starmer has drawn the wrath of Britain's farming community, who accused him of "skulking out the back like a rat" after his speech at the Welsh Labour conference in Llandudno. His retreat from hundreds of furious farmers—gathered outside to protest what they've labelled the "family farm tax"—was hardly befitting a leader, at least according to farmer and YouTube personality Gareth Wyn Jones. "He should have been man enough to come out and talk to the people," Wyn Jones seethed, branding the prime minister "disrespectful" and lamenting how he'd slunk away, tail tucked, back to London, far from the crowd demanding answers.

The Prime Minister, however, seemed untouched by the outrage outside, continuing to champion the latest Budget from Chancellor Rachel Reeves, with its eye-watering £40bn in tax hikes, including the inheritance tax overhaul. The changes mean an estimated two-thirds of farmers would now be on the hook for a 20 percent tax on their family farms—a statistic the Treasury stubbornly disputes. Starmer, naturally, said nothing about this; in fact, he seems to have made a sport of ignoring the brewing rural backlash altogether.

Meanwhile, the protesters outside—many having come with tractors in a slow, rumbling line along the resort's promenade—held signs decrying Labour's supposed war on British farming. "Enough is enough," they chanted, convinced that Labour's policies, if left unchecked, would drive the sector into ruin. Yet Starmer, apparently deaf to the clamour, exited through a back door, leaving police to keep the peace between farmers and his seemingly indifferent party.

While Sir Keir may dismiss the anger in the fields as no more than a temporary stir, the scope of the unrest suggests otherwise. Even Whitehall itself is split on how badly this new tax might hit farmers. The chancellor claims a modest 28 percent would be affected based on annual agricultural property relief applications, while figures from the Department for Environment, Food and Rural Affairs put the number as high as 66 percent.

The backlash has been fed by senior Labour figures like John McTernan, who recently opined that Britain "doesn't need family farms," and even urged Sir Keir to treat them as Thatcher did the miners in the

1980s—a comparison that could hardly have gone down worse in farming circles. In response, farmers have raised the stakes, pledging to strike and, in effect, shut down Britain's domestic food supply in the weeks ahead.

Ahead of today's demonstrations, farmers issued a message directly to the prime minister: "Sir Keir, witness the tidal wave of resentment you've stirred up with your careless policies. This inheritance tax debacle is only the latest example of your government's tone-deaf approach to rural Britain. The farming community is on the brink, and your Budget is pushing us over the edge." Their frustration reflects an industry teetering under pressures that only seem to worsen with each new tax.

For farmers like Wyn Jones, the inheritance tax changes threaten the very existence of family farms. "The government is strangling an industry already at its breaking point," he said, warning that the inevitable result would be price hikes on British food. "Who will pay for this? Not the politicians dining in London, but the ordinary people who are already struggling to afford basic necessities."

As a full-scale protest looms in Whitehall, where thousands more farmers are expected, it remains to be seen whether Starmer will continue to turn a blind eye or if the shouts from the field will finally force him to confront the fallout of his policies. For now, it appears he'll leave the farmers shouting into the wind.

Nothing Will Really Change in 2025

US Politics is not going to change much, here's why

Nothing Will Really Change in 2025
US Politics is not going to change much, here's why

There's a saying that nails it right on the head: "If voting could ever really change anything, it'd be illegal." Politicians would rather burn down the world than let the rabble have any actual influence over them. And here we are again, after the requisite rounds of theatrical moral panic, empty slogans, and empty promises, finding ourselves faced with the inevitable result: the Deep State has, of course, won the U.S. elections of 2024.

What did we expect? The great masquerade of democracy continues, with the ruling classes performing their grotesque little pageant as if the whole system isn't already rigged in their favour. Billions spent—likely pried from the very taxpayers being sold down the river—to perpetuate this pathetic illusion of choice, as though anything would truly change. They serve up their two carefully vetted candidates, one a barker for the corporatocracy, the other a handmaiden of the surveillance state, but on all the issues that keep us shackled—spying, perpetual war, ever-tightening control—not a hair's breadth of difference will come of it.

Because here's the ugly truth: regardless of which "saviour" sits in the Oval Office, there's a permanent, unelected bureaucracy pulling the strings. And they're not interested in your freedom, your rights, or any of that lovely rhetoric about "We the People." They want obedience. They want control. And they've perfected their mechanisms for ensuring they get it.

1 - The Erosion of Rights

The Constitution? That's been nothing but a historical curiosity since the "war on terror" descended upon us. Post-9/11, Americans traded liberty for a brittle illusion of security, all wrapped up in a tidy legislative package: the Patriot Act, the National Defence Authorization Act, all precisely designed to dismantle your freedoms brick by brick. The government has turned the United States into a battlefield—against its own people. The rule of law? Relegated to a quaint relic, a set of principles we pay lip service to as martial law slowly becomes the de facto standard.

2 - The War on the Citizenry

The government's war machine hasn't stopped with foreign "enemies"; no, it's made the American people its latest adversary. Think you're free? The First Amendment barely protects a whisper. The Fourth Amendment

is shredded. You no longer need to look or act suspicious to be treated like a criminal; simply exist, and the State has decided you're a suspect. American citizens are now a de facto "criminal class," subject to shootings, mass surveillance, fines, asset forfeitures, random searches, and God knows what else. They'll haul you over if you so much as blink the wrong way.

3 - The Unaccountable Bureaucratic Regime

Ah, the Deep State—that shadowy bureaucratic monolith with its corporate tentacles buried deep into the guts of government. Forget the Democrats and Republicans—those are just window-dressing for the real power: an elite entrenched, unelected, and unmoved by elections or revolts. Whoever's in office is essentially just a mouthpiece, a puppet, for a machine that was never intended to serve the people.

4 - Government Power Grabs Under the Cloak of Crisis

Every national crisis—manufactured or otherwise—is a golden opportunity for government expansion, the "emergency state" rationale justifying ever-deeper invasions of privacy, crackdowns on dissent, and, predictably, more power for the police state. The script never changes: some threat rears its head, and the government's solution is—surprise, surprise—more government. The only thing shrinking is individual liberty, swallowed whole by the Leviathan.

5 - Endless Wars for the Enrichment of the Few

The U.S. is the world's wealthiest war machine, spending an eye-watering $920 billion on defence each year, keeping the military-industrial complex flush with cash. The wars may be pointless, the deaths meaningless, but as long as the cash flows, America's military empire will keep on expanding, like some sort of grotesque cancer feasting on public funds.

6 - Government Corruption, Barefaced and Unbridled

It's no surprise, really, that the greatest threat to the U.S. is the U.S. government itself. Even the people seem to know it, with nearly three-quarters of Americans agreeing that the government is corrupt. But what does it matter? Representation is a charade, and those in power have more in common with CEOs and oligarchs than with the citizenry. They

don't serve the people; they serve the interests of wealth and power, perpetuating their stranglehold on governance and influence.

7 - Tyranny Under the Imperial Presidency

The "Imperial Presidency" is not a title given, but one taken. The President, regardless of party, is practically a monarch, accumulating powers far beyond anything the Constitution intended: they wage war without permission, spy without warrants, detain without trial. The powers grow with each successive President, creating a throne in the Oval Office that is, effectively, above the law.

A Grim Reality

This is the reality we face: the U.S. government has become the biggest danger to its own citizens—more so than any bogeyman it tries to scare us with. The average American, surveilled, controlled, and commodified, is the last thing the government has any intention of representing. And here's the irony: we're told to vote, to engage in this pantomime of democracy, as though a new President will fix what is, fundamentally, unfixable.

Billionaire Power Games

The people will always loose, the "Predator Class" will always win

Billionaire Power Games

The people will always loose, the "Predator Class" will always win

Ah, so here we are, once again, watching history repeat itself like some tragically unfunny comedy rerun. The world's "progress" amounts to little more than rebranding the thuggish playground bully as a sleek mogul in a tailored suit. We're supposed to believe that mankind has evolved from brawn to brain, from crude brute force to high-minded intellect and sophisticated industry. But in the end, what's really changed?

In the so-called "civilized" West, once home to the Renaissance—a brief, dazzling moment when we dared to value knowledge, beauty, and self-discovery—our "leadership" now finds inspiration in precisely the opposite: blind financial might. It turns out we've simply traded in the warrior's spear for the billionaire's stock options. How profound. So here we are, led not by those with ideas or integrity, but by a new tribe of tycoons whose only real talent is a cutthroat commitment to amassing wealth and wielding it like a cudgel.

Today, these paragons of "progress" have refined the power game into a new kind of financial feudalism. Power isn't swinging a club or wielding a sword; it's pressing buttons on a trading floor and watching the world grovel. It's no longer the warrior at the top of the hill—now it's the tech titan or hedge fund magnate on his private jet, looking down at a world that has been thoroughly bought and paid for. We are meant to be dazzled, to forget that beneath this facade lies the same old power-lust, now draped in the language of "innovation" and "disruption."

Witness the rise of America's billionaire-king caste, where each grotesquely wealthy individual takes their turn pretending to understand governance while grasping for influence with all the elegance of a bulldozer. And we, the audience, are expected to watch, applaud, and stay quietly in line. Now we have Musk, presiding over his tech empire with all the delicate grace of a wrecking ball, aligning himself with politicians like Trump, who's only too happy to indulge the fantasy that this billionaire cartel is somehow leading us into the future rather than pulling us backward. It's the gilded age redux—now with rocket ships and internet platforms instead of oil rigs and railroads.

We might laugh at the spectacle if it weren't so deadly serious. These self-anointed visionaries congratulate one another as though they're lifting civilization to new heights, all while stepping on anyone and anything that doesn't turn a profit. Trump and Musk might as well hoist themselves onto

pedestals of their own making, gloating over the financial empires they've cobbled together, yet devoid of any real wisdom or vision that extends beyond their bottom line.

The irony is tragic. We in the West love to cling to the illusion that we're somehow better than the warlords and despots of yore. But today's tech titans and real estate moguls are nothing more than modern incarnations of those primal thugs—driven not by public service or selfless dedication to humanity, but by an insatiable greed masquerading as success. These "leaders" boast about disruption and innovation, but they merely reinforce the status quo: they uphold a world where wealth is king, human value is defined by market share, and ethical principles are just obstacles to be bulldozed.

Some would argue that this billionaire elite is a necessary counterweight against governmental and corporate overreach, a check on the powers of the "deep state." But let's not fool ourselves. They're hardly interested in revolutionizing society for the greater good. If anything, they're reshuffling deck chairs on a sinking ship, profiting from the chaos they themselves create.

And so, this is where we find ourselves: in a world mesmerised by Mammon, where financial power has replaced any semblance of true leadership. A civilization that has turned its back on the pursuit of wisdom and truth, now gazing with awe upon the hollow grandeur of a moneyed elite whose only aspiration is to aggrandize themselves further. Real progress—the kind that elevates the human spirit, that seeks liberation and justice for all—is smothered beneath this grotesque charade.

True civilization, as Gandhi so wisely said, is not in amassing wealth, but in shedding the empty desires that fuel this meaningless accumulation. Until we recognize this, until we can prioritize values that transcend materialism, we are fated to remain prisoners in a system that promises freedom but only offers gilded chains. Let the self-proclaimed kings of wealth revel in their illusion of power; the rest of us should look beyond their crass ambitions, toward a world built on something more enduring than the cult of Mammon.

Labour's Socialist Agenda

Welcome to Hell, it sucks here...

OBLIVIONMEDIA.SUBSTACK.COM

Labour's Socialist Agenda

Welcome to Hell, it sucks here...

Labour is a party of doctrinaire zealots, relentless in their mission to embed their ideology into the nation's bones. Political power isn't a means to better the lives of the British people; it's a stepping stone toward cementing their ideals in government and grinding opposition underfoot. The health of the nation, and the needs of its people, are merely inconvenient distractions to be pacified, ignored, or, when absolutely necessary, silenced.

The party's approach is not rooted in the real, tangible world. Instead, it clings to a deranged faith in abstractions like Net Zero, Diversity and Inclusion, multiculturalism—empty catchphrases for minds completely detached from reality. Labour has long been wary of the working man, who, patriot at heart, is too fond of his own freedom, his own ambitions, and his own self-worth to blindly follow their schemes. Far too concerned with practical needs and family well-being, he cares little for being pawed into an ideological mold. He is a danger to the movement.

Business, too, has proven an elusive partner for Labour's statist plans. For Labour and its brain trust, the solution was always to assert national socialism as a stepping stone to international socialism, an international cage for Britain where no one—not a business, not a worker—could escape their control. The Fabians were explicit about it; for socialism to survive, it had to be worldwide, because if the British people had options —be they business choices, individual freedoms, or foreign opportunities —then the house of cards would crumble.

The dreamers at Labour hold their contempt for sovereignty close. To them, a true socialist is a serf to the collective, subjugating individuality, enterprise, and self-interest to some hollow idea of the "greater good." But there's a grotesque irony here: to bring their vision into reality, they ironically champion the very mechanisms they claim to loathe—the Empire, global regulations, even the imposition of "civilization" upon the recalcitrant. If necessary, they have always been willing to wield violence in its name. Annihilation was Shaw's preferred euphemism, a testament to the inhumanity of their ethos.

This is the party of Starmer and Reeves, whose loyalties lie not with Parliament or with British voters, but with international power brokers, with the Davos crowd. For Starmer, the British Parliament is too "parochial" to matter much; why care about the opinions of the very

30

people who elected him when a handful of global elites know so much better? Reeves, for her part, decorates her office with a portrait of "Red Ellen" Wilkinson, Communist Party founder and Moscow pilgrim, whose ideological lineage has led to nothing but human suffering and historical devastation.

The family farm is Labour's latest target, treated as an enemy to be vanquished, a relic to be removed. It embodies three ideals—family, profit, and heritage—that Labour finds intolerable. A Caucasian farmer, grounded in Britain's traditions and tied to the land, is a direct affront to the left's world-view. Unfit for the pantheon of diversity deities and stripped of protection in a world Labour seeks to make hostile to his existence, he is the modern-day Kulak, a class to be erased for the "greater good."

Blairite strategist John McTernan said it bluntly: Britain doesn't need its farmers, small businesses, or family-owned enterprises. Labour can wipe them off the map just as Thatcher did to the miners. Reeves and Starmer can pretend to renounce McTernan's views all they like; their actions tell the truth. It's not about keeping the national interest at heart. It's about a future where the British people lose their voice to an international order— a future Labour will stop at nothing to impose.

A 500 Word Challange

Why I hate 21st century education

A 500 Word Challenge
Why I hate 21st century education

In 2021, I made the ill-fated decision to return to education, hoping to sharpen my skill set and elevate my intellectual repertoire. What a spectacular train-wreck that has turned out to be. Optimism, as it turns out, was my first mistake.

My inaugural assignment was deceptively simple on the surface: craft an essay, capped at a measly 500 words, on the impact of the printing press on the Reformation and—because academia thrives on baffling tangents—the world of music. What an exercise in futility. Naturally, I approached this task with the diligence of someone who actually cares about nuance and depth. Hours of research later, I emerged with what I generously dubbed a "basic essay"—a sprawling 5000-word tome, the introduction alone devouring 600+ words.

Cue the back-and-forth with my tutor, an individual whose feedback was as lukewarm as a stale cup of tea. Their pearls of wisdom? "Just do what you can to edit it down." Brilliant advice, truly. With that profound guidance ringing in my ears, I was left to butcher my essay into a shadow of its former self. What follows is the resulting abomination, hacked and trimmed to meet the arbitrary word count of a system more interested in brevity than substance.

The invention of the printing press in the mid-15th century by Johannes Gutenberg was perhaps humanity's first step toward drowning itself in an endless deluge of hastily reproduced ideas, many of which should have been left to die in the scribes' monasteries. It transformed the dissemination of information into a chaotic free-for-all, setting the stage for the Protestant Reformation and the inexorable commodification of music. This infernal contraption gave the masses access to theological tracts and musical scores, unleashing a torrent of both inspired genius and insipid drivel upon an unsuspecting Europe.

The Reformation, that great ecclesiastical fistfight masquerading as a moral awakening, found its unlikely champion in the printing press. Martin Luther, ever the rabble-rouser, weaponized this new technology to peddle his 95 Theses far and wide. Within months, what could have remained a localized theological squabble became Europe's hottest controversy. Previously, the Catholic Church's stranglehold on the written word had spared the public from the chaos of individual interpretation. But the printing press shattered that monopoly, making books cheaper and more

accessible to a burgeoning middle class, who were suddenly drunk on the delusion that they could grasp divine mysteries. Luther's vernacular Bibles encouraged common folk to fancy themselves theologians, fostering a delightful cacophony of misinterpretations that fractured Christendom into innumerable squabbling sects.

Music, too, was enlisted in this ideological free-for-all. Reformers, keen to exploit every avenue to control the hearts of the gullible, understood the manipulative power of a catchy tune. Luther, who fancied himself something of a composer, churned out hymns designed to indoctrinate congregations with Protestant theology. The printing press ensured these chorales could be mass-produced and sung by peasants in their own languages—a calculated move to bypass the Catholic Church's reliance on lofty Latin compositions. What was once the sacred art of choral music became, thanks to Luther and his ilk, the primitive sing-along fodder of the unwashed masses.

Beyond the Reformation, the printing press spawned the music publishing industry, for better or worse. The first printed music book, Harmonice Musices Odhecaton, appeared in 1501, ushering in an era where composers like Josquin des Prez and Palestrina could achieve fame beyond their own courts and cathedrals. While this allowed brilliance to flourish, it also meant that mediocre talents could flood the market with derivative works. Worse yet, amateurs, armed with cheap sheet music, began mangling madrigals and butchering ballads in their parlours, heralding the rise of domestic music-making as a tasteless pastime.

In the end, the printing press gave humanity what it always craves: more. More ideas, more songs, more noise. It democratized access to knowledge and art, for better and for worse, ensuring that brilliance and stupidity alike could spread unchecked. It revolutionized history, yes, but not without reminding us that when given the tools to create and share freely, humanity will always, inevitably, overdo it.

Star Trek IV & Military Censorship

A Dance of Propaganda and Petty Politics

Star Trek IV & Military Censorship
A Dance of Propaganda and Petty Politics

Star Trek IV: The Voyage Home—or as the unwashed masses lovingly recall it, the one with the whales. While the franchise is often praised for its forward-thinking vision of humanity's future, this particular entry doubles as a stark reminder of just how deeply the United States military has its tentacles wrapped around Hollywood's throat. It's not just a partnership; it's a symbiotic relationship of mutual exploitation, with Tinseltown ogling shiny war toys and the Pentagon leering at the silver screen, eager to polish its image for the popcorn-munching public.

The quid pro quo is simple: film-makers get to borrow warships, jets, and archival footage to add a veneer of authenticity to their cinematic fantasies, while the Department of Defence gets final say over scripts to ensure Uncle Sam always looks like a dashing hero. That brings us to 1986, when the Pentagon's puritanical film office took offence at Star Trek IV's portrayal of the Navy, leading to a battle of egos and edits that fundamentally reshaped the movie.

The Pentagon Takes Offence

Enter Don Baruch, long-time czar of the Pentagon's film office and self-appointed protector of America's military image. Baruch took one look at Star Trek IV's script and saw red. The screenplay dared to depict Navy shore patrol-men as bumbling incompetents and suggested security aboard the nuclear aircraft carrier USS Enterprise was, gasp, less than airtight. Sacrilege! A military institution entrusted with humanity's deadliest toys must never, ever be portrayed as fallible, especially not in the whimsical world of time-travelling starships and space whales.

In truth, the Pentagon's gripe boiled down to a toddler's tantrum: it didn't want its toy soldiers looking bad in a movie where literal spacemen save the planet. Heaven forbid the Navy's image endure the scandal of a Russian officer outwitting their guards or, even worse, bumbling Americans accidentally shooting him.

Harve Bennett's Diplomatic Dance

Harve Bennett, the film's producer, was blind-sided by the military's hissy fit. This was Star Trek, for crying out loud, a franchise that revered the Navy so much it practically lifted Starfleet's command structure wholesale. Bennett, a self-proclaimed patriot and future recipient of the

Department of Defence's Outstanding Civilian Service Medal, thought he'd done everything right. He even dusted off a 1970s made-for-TV movie he'd produced on the USS Ranger to prove his Navy-friendly credentials. But Baruch wasn't biting.

Desperate, Bennett enlisted Hollywood's go-to Pentagon whisperer, John Horton, who set up a meeting with the Navy's Information Office. The result? A laundry list of script changes designed to scrub away any whiff of naval imperfection. What followed was a rewriting frenzy so absurd, it's a wonder the movie didn't implode under the weight of its compromises.

From Intrigue to Blandness: A Script Neutered

The original script had flair: Chekov and Uhura sneaking onto the USS Enterprise like Cold War commandos, evading tripwires, stunning guards, and raiding a secure nuclear facility to save the future. It was tense, clever, and unabashedly pulpy. Naturally, the Pentagon hated it. Every line that hinted at naval fallibility was excised with surgical precision.

No more daring infiltrations. Instead, Chekov and Uhura's entry onto the aircraft carrier is implied to involve beaming—an off-screen deus ex machina so vague it's practically insulting. No more guards being stunned; the offending scenes were sanitized to show Chekov simply falling and knocking himself unconscious like a Keystone Cop.

The interrogator? Rewritten as an FBI agent to spare the Navy from looking dumb. The hospital escape? Stripped of its tension, with San Francisco police subbed in for naval shore patrol-men. Even Kirk's climactic escape from the roof was watered down: no more phaser stand-offs; just a quick beam-out from an elevator. By the time the military was done meddling, the Navy's involvement in the movie had been reduced to that of a clueless bystander.

The End Result: A Mediocre "Classic"

Critics hailed The Voyage Home as a heart-warming romp with a pro-environmental message. Sure, if you squint past the gaping plot holes and neutered tension, it's cute in a Saturday-morning-cartoon sort of way. But for anyone with a taste for science fiction that challenges, innovates, or even just takes itself seriously, it's a mess.

The military's censorship turned it into a bland crowd-pleaser devoid of real world high stakes. And for what? So the Navy wouldn't look bad in a movie about time-travelling spacemen? The irony is almost too much.

They feared looking foolish and, in the process, revealed their obsession with control and image at the expense of art.

Star Trek IV may be remembered as a franchise high point by those who value kitsch over quality, but for this fan, it's a low-tier entry at best. It's not science fiction; it's sanitized nonsense wearing the skin of a franchise that once promised bold exploration and ingenuity. No wonder the whales went extinct.

The Grand Saga of Electrification

A bridge to nowhere.

The Grand Saga of Electrification
A bridge to nowhere.

What began as a daring frontier of innovation, a chaotic free-for-all where ambition sparked and wires tangled across urban landscapes, has devolved into yet another cautionary tale of greed, politics, and human short-sightedness. What was once the domain of engineers and inventors solving tangible problems is now the playground of politicians, activists, and corporate bureaucrats, spinning grandiose narratives while quietly passing the bill on to you.

In the early days, it was messy but honest. Companies competed to power cities, neighbourhoods, and industries in an unregulated frenzy. Sure, it was inefficient, and yes, public safety occasionally fell victim to crossed wires and corporate rivalries, but the goal was clear: deliver power, keep the lights on, and expand the possibilities of modern life. The monopolies that emerged—regulated by state public utility commissions (PUCs)—were supposed to simplify and stabilize this, ensuring reliable electricity for everyone, everywhere, at reasonable rates. For a time, it worked. Engineers focused on balancing supply and demand, building resilient grids, and ensuring backup capacity.

But, of course, nothing good lasts when politics sinks its claws into it. Fast forward a few decades, and what do we find? A system no longer grounded in pragmatism but hijacked by political whims, ideological crusades, and corporate opportunism cloaked in moral platitudes. The once straightforward mission of keeping the lights on has been subordinated to the altar of "climate change," where the fantasy of net-zero emissions reigns supreme.

Let's not mince words: the drive for net-zero has nothing to do with reliability or affordability, the original promises of the electric utility monopolies. It's about optics. It's about pandering to an increasingly radical political agenda while pretending to save the planet. And, oh, how the utilities have adapted! They've learned to play the game, milking the system for subsidies, tax credits, and guaranteed profits for every windmill, solar panel, and battery farm they slap onto the landscape. They don't care if these "solutions" destabilise the grid or send energy bills skyrocketing. Why would they? They've been indemnified against failure. When the power goes out, they shrug and point to ageing infrastructure or extreme weather—the political equivalent of "the dog ate my homework."

Remember when utilities fought to keep coal and natural gas plants open, warning that a premature shift to renewables would be catastrophic? Those were the good old days, when at least someone in the industry was pretending to care about grid stability. Now, they've capitulated completely. Why fight when the system pays you more to build expensive, unreliable power sources than to maintain affordable, dependable ones? Wind and solar farms are cash cows, not because they work better, but because the government ensures they're profitable —even if they fail miserably at their job.

And let's not forget the PUCs, those erstwhile watchdogs of the public interest. Once tasked with ensuring utilities served their customers reliably and affordably, they've been co-opted into the decarbonisation charade. Their primary role now is rubber-stamping every overpriced, underperforming "green" project the utilities dream up, all while feeding rate-payers the soothing lie that this is progress.

The irony, of course, is that this relentless march toward renewables isn't even about saving the planet. It's about power—political power, corporate power, and the power to virtue-signal on a global stage. Every utility company website now boasts of its commitment to net-zero as if slapping a wind turbine on their logo will make up for the fact that they can no longer keep the lights on when the sun doesn't shine or the wind doesn't blow. Meanwhile, reliable and relatively clean energy sources like nuclear are quietly sidelined because they don't fit the ideological narrative or deliver the same short-term financial windfalls.

So here we are, trapped in a farce of our own making. Electricity is no longer about utility but about ideology. The grid grows more fragile, the costs climb higher, and the people footing the bill—the rate-payers, tax-payers, and citizens—are left in the dark, both literally and metaphorically. Welcome to the 21st century, where the "wild west" of electrification has been replaced by the equally chaotic and infinitely more cynical spectacle of the "green revolution." But don't worry; at least the corporate sustainability reports look great.

World Bank Under Fire as $24 Billion in Climate Cash Mysteriously Vanishes

But Hey, Who's Counting?

World Bank Under Fire as $24 Billion in Climate Cash Mysteriously Vanishes

But Hey, Who's Counting?

The World Bank: that self-appointed saviour of the planet, poised to solve humanity's greatest crisis—climate change—with the small caveat that it can't seem to keep track of tens of billions of dollars. Between $24 billion and $41 billion of climate finance disbursed in the past seven years has vanished into the ether, according to Oxfam. To put that into perspective, that's nearly 40% of all the funds it handed out in this period. Imagine losing 40% of your groceries on the way home and then shrugging it off. Only, in this case, it's not misplaced apples but billions meant to save the world.

And yet, the reaction from the World Bank? A nonchalant blend of bureaucratic deflection and wilful oblivion. According to one insider, who wisely opted for anonymity, the real amount unaccounted for could be "twice or 10 times more." Twice or 10 times? Why not throw in a random number generator for good measure? This isn't just negligence; it's a masterclass in institutionalised incompetence. The insider's blunt confession—"all the figures are routinely made up"—suggests the World Bank is less a financial institution and more a black hole for well-intentioned cash.

Let's not pretend this is a new problem. The World Bank's accounting practices, which track funds at the moment of project approval rather than completion, are practically engineered to obscure reality. It's the fiscal equivalent of celebrating a marathon finish after tying your shoelaces. That such a glaring flaw has persisted for years suggests not just incompetence but an unwillingness to be held accountable.

Oxfam's report, Climate Finance Unchecked, meticulously details the labyrinthine process of chasing down even the most basic information about these funds. Researchers were forced to wade through incomplete reports riddled with gaps, contradictions, and enough red tape to gift-wrap the planet. The message is clear: transparency isn't a priority for the World Bank. Why should it be? Accountability is for the plebs, not global institutions with $100 billion pledges to burn.

The most infuriating aspect? The communities these funds are supposed to benefit are the least likely to see a dime. Billions earmarked for mitigating climate disasters, transitioning to sustainable energy, and

protecting vulnerable populations instead vanish into a fog of bureaucracy, mismanagement, and likely corruption. Meanwhile, the World Bank continues its performative charade, parading its "ambition" at climate summits while evading even the most basic scrutiny.

And so, as world leaders pat each other on the back at COP29, debating grandiose targets and net-zero commitments, one of the central pillars of climate finance is revealed to be little more than a leaky bucket. Calls for reform abound, but forgive the cynicism: why would a system that profits from opacity suddenly embrace accountability? The real outrage isn't just that the money is missing—it's that no one seems genuinely surprised.

A Cynical Appraisal of Euthanasia

This is going to be polarising...

A Cynical Appraisal of Euthanasia
This is going to be polarising...

I've heard it said—often with the earnest conviction of someone who thinks they've stumbled upon a grand revelation—that if a pet were left to suffer in unrelenting agony due to illness or old age, you'd be hauled before the courts for cruelty. And, some may be shocked to know, I agree with this argument. But don't get your hopes up for a flicker of compassion here—this isn't even that kind of conversation.

Let us strip away the euphemisms and propaganda about "dignity" and "choice" to uncover the grim reality of euthanasia. While proponents frame it as a compassionate option for the terminally ill, the evidence, history, and logic all point to a far darker and more insidious outcome.

The Thin End of the Wedge

When euthanasia is legalised, the "strict safeguards" and "clear guidelines" are little more than window dressing. The precedent is well established: legal boundaries erode with alarming speed. Need proof? Recall the overuse of midazolam and the chilling application of Do Not Resuscitate (DNR) notices during the COVID-19 era in the UK. These measures, ostensibly to "protect resources," conveniently targeted the most vulnerable—elderly and disabled patients—while society averted its gaze.

The Blackmail of the Vulnerable

Experience from other countries shows the slide from voluntary euthanasia to coercion is as predictable as it is horrifying. Once the option exists, pressure mounts on individuals to "do the right thing" and end their lives to spare their families financial or emotional burdens. Even the healthy can find themselves manipulated by moral guilt trips, psychological harassment, or outright blackmail to consent to their own demise. This is not choice; it's extortion with a scalpel.

A Breach of Ethics and Humanity

Killing another human being is a violation of ethics, human rights, and international law—unless, of course, you're a politician in a sharp suit declaring it's for the "greater good." Let us not forget the Nuremberg trials, where euthanasia was condemned as an unforgivable atrocity. Yet, here we are again, dressing up the same horror in modern rhetoric.

Dr. Vernon Coleman aptly points out the absurdity: "It is immoral to allow politicians to decide that doctors and patients may conspire to end a life." Such legislation does not enhance dignity; it annihilates it.

The COVID Euthanasia Trial Run

During the lockdowns of the so-called "COVID pandemic," a trial run for institutional euthanasia was quietly conducted. Thousands of elderly patients were killed using cocktails of midazolam and morphine under the guise of "protecting the NHS." The media was silent. The public, pacified by fear, offered no resistance. This was euthanasia in practice—disguised as crisis management. Don't think for a moment that this was a one-off; it was a blueprint.

DNR: A License to Kill

What began as a compassionate tool for avoiding futile resuscitation attempts has metastasized into a bureaucratic shortcut to neglect. DNR orders are now slapped on patients—often without their consent or even knowledge—allowing hospitals to withhold treatment for anything from infections to heart attacks. To add insult to injury, patients are lied to, told that resuscitation is "too painful" or "unlikely to work." In reality, this is simply a cost-saving exercise thinly veiled as care.

Euthanasia for All—Coming Soon

If euthanasia is legalised, the domino effect will be unstoppable. Rules will change, just as they have in other countries. Children will soon be allowed to choose death, courts will strip parents of authority, and "care homes" will be transformed into budget-friendly death camps. In France, pro-euthanasia groups already lobby for "death centres" where the terminally ill can be conveniently disposed of. Let's call them what they are: cost-cutting extermination facilities.

Euthanasia Violates Human Rights

The prohibition of killing is not some quaint moral relic—it is the bedrock of civilised society. The European Convention on Human Rights explicitly forbids the intentional deprivation of life, yet pro-euthanasia advocates are determined to undermine this fundamental principle. As seen in other countries, once the practice is normalised, the scope widens to include the disabled, elderly, poor, and anyone else deemed "expendable."

The Myth of Choice

Pharmacists and medical professionals will not escape unscathed. Today, a pharmacist dispensing lethal drugs would be prosecuted for complicity in poisoning. Under euthanasia laws, the same act could become mandatory. So much for conscientious objection. The law will not protect them any more than it protects the vulnerable from coercion.

The Death of Debate

The pro-euthanasia movement thrives on silencing dissent. Media outlets parrot the party line, and critical voices are marginalised or ignored. Even Dr. Jack King, author of a bestselling exposé on euthanasia, was shunned by broadcasters. Public discourse is manipulated to ensure euthanasia is presented as a panacea, with no regard for the profound ethical and societal consequences.

The Grim Future

Let us be clear: euthanasia is not about "choice." It is about normalising death as a solution to societal problems. It is cheaper to euthanise than to care, and governments, ever eager to balance budgets, will exploit this to the fullest extent. The most vulnerable—those who need our compassion the most—will bear the brunt of this chilling new reality. And all the while, we will tell ourselves it's "compassionate" and "progressive."

Make no mistake: legalising euthanasia is not a slippery slope; it's a free-fall into an abyss where human life is measured in financial spreadsheets and moral convenience. The safeguards are a sham. The rhetoric is a lie. And the consequences will be irreversible.

We Need To Talk Magna Carta

It's not what you keep saying it is!!!

We Need To Talk Magna Carta

It's not what you keep saying it is!!!

The level of historical and legal illiteracy in Britain never ceases to astound. It's not just ignorance—it's ignorance worn as a badge of honour, particularly among the self-styled "Patriot" movement. But then again, what should we expect? The British version of this farcical parade is little more than a badly annotated, third-rate photocopy of the flag-waving, God-bothering lunacy exported from across the Atlantic. If America's Patriot movement is a carnival of delusion, Britain's is the sad, rain-drenched travelling fair that shows up three weeks late and charges extra for the Ferris wheel.

Let me break this down for anyone still waving their St. George's Cross while ranting about "common law rights" in their poorly punctuated social media posts. Britain is, in fact, a union of countries operating under a constitutional monarchy. Further more, the so-called "constitution" isn't a tidy document like America's Bill of Rights, but a sprawling, chaotic web of case-law, statutes, customs, and conventions. It's not written on parchment; it's scrawled across centuries of legal wrangling and parliamentary double-dealing, with all the coherence of a drunk trying to explain the rules of cricket.

And yet, these proud nationalists —who've clearly never cracked open a history book that didn't have the word "conspiracy" in the title—cling desperately to the Magna Carta as if it's some proto-Bill of Rights. This is not just wrong; it's an embarrassment to the concept of wrongness. Magna Carta was a feudal document hammered out between a tyrannical king and a bunch of proto-landed gentry, The Barons who were fed up with being extorted to fund his latest failures. It wasn't about liberty, democracy, or freedom of speech. It was about not having your lands confiscated because King John fancied another go at Normandy.

Yes, King John—a real historical figure, not merely the snarling pantomime villain of Robin Hood lore. The man, the myth, the monumental failure. Let us pause to marvel at the walking disaster who managed to unite a gaggle of self-serving barons—not through charisma or statesmanship, mind you, but through sheer, unrelenting incompetence and malice. Truly, his was a reign that could make even the most indifferent nobleman say, "You know what? Let's risk everything to dethrone this clown."

King John is a historical case study in how to royally fumble power. If medieval monarchy were a popularity contest, John would have been booed off the stage faster than you could say "Rochester". His reign (1199–1216) was a comedy of errors, marked by failures so spectacular they became the foundation of modern governance—largely by teaching everyone what not to do.

Let's start with John's diplomatic finesse, which rivalled that of a drunken hedgehog. His older brother, Richard the Lionheart, had squandered the royal treasury on crusades, leaving John a kingdom in debt and bristling with discontent. Rather than showing even a shred of strategic competence, John immediately alienated his barons by levying absurdly high taxes and confiscating estates like a petty tyrant with no concept of long-term loyalty.

His military career? A masterclass in how to lose everything you touch. He managed to surrender Normandy to France in 1204—a humiliation that even his contemporaries couldn't overlook. For a king whose job was essentially "don't lose land," John was spectacularly bad at it (earning him the moniker "John Softsword"). But his ineptitude didn't stop there. When Pope Innocent III appointed Stephen Langton as Archbishop of Canterbury, John refused to accept it, leading to his excommunication and an interdict over England. For years, English churches were closed, sacraments denied, and John still thought he was winning. John was the kind of ruler who didn't just alienate his allies; he actively seemed to revel in it.

Domestically, John turned England into his personal cash-cow, squeezing the nobility, clergy, and commoners alike to fund his ill-fated military campaigns. He invented creative ways to fleece his subjects, from arbitrary fines to exploiting feudal customs. And when people couldn't pay? John had no qualms about imprisoning them or holding their relatives hostage. The man was a tyrant so petty, he allegedly starved opponents to death in his dungeons.

His personal life wasn't much better; he reportedly seduced the wives and daughters of his own vassals, presumably because undermining loyalty on every possible front was his version of multitasking. The man was so loathed that chroniclers of the time didn't even need to embellish his misdeeds—his life read like a satire all on its own.

But let's not forget his crowning achievement: driving the barons to radical action. It takes a special kind of mismanagement to push a group of feudal overlords—men who were already fat and happy on the

exploitation of peasants—to band together and risk their cushy lifestyles in the name of reform. Reform, of course, being code for "stop John from ruining our lives." This wasn't an uprising of the downtrodden but a revolt of the privileged, fed up with their king acting like a petty tyrant who couldn't even do tyranny well.

By 1215, his barons, tired of being bled dry by a king who couldn't win wars or keep his promises, finally snapped. Their revolt forced John to sign the Magna Carta, a document that basically said, "Hey, maybe don't treat your vassals like dirt." Of course, John didn't actually intend to follow it; he just signed to buy time. Within months, he was back at war with the barons, who invited Prince Louis of France to take the throne. That's right —John was so loathed, his own nobles would rather back a Frenchman.

John's reign ended in 1216 when he died of dysentery, fittingly brought low by bad planning and poor judgment, even in his choice of meals. His legacy? A lasting reminder that incompetence, cruelty, and greed make for a lousy ruler but excellent material for constitutional reform.

Okay, let us get to that legal legacy that nationalist groups have wet-dreams over.

The Magna Carta—fetishised by the historically illiterate as the cornerstone of liberty and justice. But here's the rub: it was never meant for the likes of the common rabble. The barons who forced King John's hand in 1215 weren't championing universal rights; they were aristocrats demanding the king stop screwing them over quite so blatantly. The serfs? The peasants? The muck-dwellers? Not a single clause of that hallowed document was penned with their grimy lot in mind.

The Magna Carta was a power shuffle among the elite, a squabble between entitled feudal overlords. It wasn't some benevolent gift of freedom for every grubby hand in the kingdom. Why would it be? The idea of "rights" for the unwashed masses would've sent these barons into fits of laughter—likely between swigs of mead and bouts of exploiting the very serfs who now cling to this document as some mythical relic of equality.

Even today, its application to "common people" is a romanticised fairy tale. Yes, some of its principles trickled down over centuries, but only after being wrung through generations of bloodshed, legal wrangling, and societal upheaval. The truth is, Magna Carta's primary legacy is symbolic —a nice, shiny bauble for people who like to pretend history is tidy and noble. In reality, it's an elitist pact born of self-interest that owes nothing

to the peasants of yore—or the modern ones, for that matter. Magna Carta was largely irrelevant by the time the ink dried and has been functionally obsolete for most of the intervening centuries. To claim it as a cornerstone of modern British liberty is like insisting your ancestral rights derive from the rules of jousting. It's fantasy dressed up as historical insight, a laughable cocktail of legal half-truths and nationalist delusion.

The real tragedy? This nonsense clogs the airwaves and public discourse, drowning out any actual understanding of Britain's constitution or governance. Instead of engaging with the messy, pragmatic reality of how laws and rights have evolved, the "Patriot" brigade demands a return to some mythical golden age of liberty that never existed. It's not patriotism; it's cosplay, performed with all the intellectual rigour of a child insisting they're the king of the playground.

The Spectre of Thatcher

A legacy Britain just can't shake.

OBLIVIONMEDIA.SUBSTACK.COM

The Spectre of Thatcher
A legacy Britain just can't shake.

On the 28th of November 2024, the Reform Party made yet another bid for relevance by parading their latest acquisition: former Conservative minister Andrea Jenkyns. Her defection—so conveniently timed to coincide with her being declared member number 100,000 on their undoubtedly inflated membership roll—was met with the kind of nauseating, self-congratulatory glee we've come to expect from Nigel Farage. He, the perennial ringmaster of this political circus, could barely conceal his delight as he basked in the media spotlight like a sunburnt seal clapping for sardines.

For anyone unfortunate enough to have followed my musings on the Reform Party, you'll know I've repeatedly likened them to the Conservative Party of 30 years ago—because, frankly, they are. A Frankenstein's monster stitched together from the rotting ideals of Thatcher-ism, sprinkled liberally with the faux populism of Farage's egomaniacal cult of personality. And yet, just in case there was any lingering doubt, Jenkyns herself helpfully confirmed during a live interview on GB News (because of course it was GB News) that her political alignment with Reform was rooted in "Thatcherite values." Thatcherite values. As if that phrase doesn't send shivers down the spines of anyone old enough to remember what those values actually meant.

Let's not forget, Farage made his bones as a Thatcherite water-carrier back in the day, schlepping her free-market dogma like a smug wine merchant peddling overpriced plonk. His career since has been an odyssey of opportunism, flip-flopping between dubious political movements with all the grace of a man trying to chase two hares at once, driven by a toxic cocktail of nostalgia for Thatcher-ism and the garish showmanship of American-style personality politics. He's the political equivalent of a boomer on a Harley Davidson, roaring down a cul-de-sac of relevance, mistaking noise for progress.

What's most galling, though, is how Thatcher's catastrophic legacy seems to be enjoying a bizarre resurgence among nationalist circles. These people—blessed, or perhaps cursed, with the attention spans of goldfish—have somehow developed a collective case of cultural amnesia. They now hail The Iron Lady with a reverence that would be comical if it weren't so tragically delusional. It's the same sycophantic veneration their transatlantic counterparts reserve for that Gipper-in-chief, Ronald Reagan

—another walking disaster whose policies haunt us like the ghost of neoliberalism past.

So, let me be perfectly clear: Thatcher-ism was a shit-show. An unmitigated, unapologetic shit-show. It hollowed out industries, crushed communities, and sowed the seeds of inequality that still fester today. If you think otherwise, you've either forgotten or you weren't paying attention. Either way, buckle up, because it's time for a little history lesson. This ride isn't just bumpy—it's a crash course in why some legacies should be left buried.

Margaret Thatcher's tenure as Prime Minister of the United Kingdom was a dystopian carnival of blunders dressed up as triumph. Her policies, rooted in a cold, transactional ideology that valorized greed and privatization, left a legacy of societal fractures and economic disrepair that lingers like a bad hangover.

Thatcher's economic policies, championing deregulation and market liberalization, bulldozed through industries with reckless abandon. Whole communities, particularly in the North, were sacrificed on the altar of neo-liberal dogma. The closure of coal mines and other heavy industries wasn't just an economic shift; it was a deliberate gutting of the working class. The promised "trickle-down" wealth never materialized—unless you count the steady drip of despair into the lives of those left unemployed.

The infamous Right to Buy scheme was a master-stroke of short-term opportunism masquerading as empowerment. Council tenants were sold the dream of home-ownership while the government sold off housing stock at bargain-basement prices. The result? A catastrophic decline in social housing availability, leaving future generations to grapple with astronomical rents and homelessness. Thatcher mortgaged the social fabric of the UK for cheap political gains.

Her frenzy for privatization turned essential services into profit-driven ventures. Utilities, transport, and telecommunications were auctioned off to the highest bidder. The public got the raw deal: skyrocketing costs, declining service quality, and the indignity of being told it was all for their own good. Britain became a laboratory for greed, with the public cast as unwitting guinea pigs.

Thatcher's war wasn't just on unions or the working class—it was on the very idea of collective responsibility. Her infamous declaration, "There is no such thing as society," wasn't a policy statement; it was a battle cry against human decency. Charity and volunteer-ism were supposed to

patch up the wounds inflicted by her cuts, an absurd expectation bordering on the sociopathic.

The poll tax, Thatcher's crowning absurdity, managed to enrage the nation across class lines. It was a tax so spectacularly unfair and regressive that it ignited mass protests and riots, proving that even her staunchest supporters had their limits when it came to swallowing her toxic policies.

Thatcher didn't govern; she ruled, sowing division with Machiavellian glee. North vs. South, public sector vs. private, unions vs. government— her every move was calculated to pit groups against each other, leaving a fractured nation in her wake. Her era was one of simmering animosity, her policies like acid slowly eroding the bonds of community.

Let us not forget the international stage as well. The rise of the neo-conservative (neo-cons) class – who were really neo-liberals, and I will use the two terms interchangeably - during the reigns of Margaret Thatcher and Ronald Reagan was nothing short of an ideological coup, a victory lap for unrestrained greed masquerading as governance. It marked the ascendancy of a cabal of smug, self-satisfied technocrats whose guiding philosophy could be summarized as "If we can't profit from it, it doesn't matter."

Neo-cons emerged from the wreckage of post-war consensus, slithering into power on the promise of "freedom" while shackling everyone else to the whims of capital. They wrapped themselves in the flag and paraded their disdain for the public good, elevating selfishness to a moral virtue. The mantra was simple: let the rich get richer, and let the poor learn to suffer with dignity—or, better yet, invisibly.

Thatcher and Reagan were the perfect demagogues for this movement, weaponising platitudes about "self-reliance" and "small government" to dismantle social safety nets. Neo-cons weren't just content to let the ladder be pulled up after them; they set the bottom rungs on fire for good measure.

Neo-cons cloaked their barbarism in economic jargon, treating Milton Friedman's gospel of deregulation like scripture. They preached "free markets" while ensuring monopolies and oligarchs were free to exploit with impunity. It was the economic equivalent of tossing a pack of wolves into a petting zoo and calling it "liberation."

In practice, this meant a wholesale looting of the public realm. Banks, corporations, and cronies were given the keys to the kingdom, while unions and communities were crushed underfoot like an inconvenience.

The neo-cons smiled as they dismantled industries, assuring everyone that the "invisible hand" of the market would take care of it. Spoiler alert: it didn't.

The neo-con ethos infected every corner of society. Art became commodity; education, a tool for producing obedient workers; healthcare, a luxury for the lucky few. Their vision of the world was a grey dystopia where everything had a price, and nothing had value. They took the vibrant post-war dream of progress and smothered it in a haze of stock options and advertising slogans.

On the global stage, they waged wars, both literal and economic, to cement their vision of a world where military might and corporate profit reigned supreme. To them, war wasn't a tragedy; it was a business model. Their military adventurism was less about strategy and more about keeping the arms manufacturers well-fed. And since we are talking about war, let's address the elephant, or should that be war-hawk in an Armani suit in the middle of the room...The Falklands War.

The Falklands War was a bizarre colonial cosplay staged in 1982 by a declining empire desperately trying to flex its atrophied muscles. Britain dusted off its long-unused jingoism to bellow its way into a 10-week skirmish over a collection of windswept rocks in the South Atlantic, home to more sheep than people. It was less a war than a performative temper tantrum, a nationalist fever dream disguised as foreign policy.

Argentina, under its own crumbling junta, decided to stake its claim over the Falklands, known locally as the Malvinas. Britain, caught in the throes of post-imperial decline and the Thatcherite project of nationalistic posturing, responded with a level of indignation normally reserved for someone cutting in line at a fish-and-chip shop. For a nation that had cheerfully relinquished actual significant colonies just decades earlier, this sudden interest in a patch of barren land was both laughable and tragic.

The conflict was a slapdash affair, marked by a mix of British military pride and the undeniable sense of trying too hard. Royal Navy task forces were sent halfway around the world to recapture what amounted to a geopolitical afterthought.

The battles themselves were brutal but strangely lopsided. Britain had its Harriers and destroyers, while Argentina's military was cobbled together from a mix of under-trained conscripts and dubious Soviet-era hand-me-downs. It was the military equivalent of kicking a downed opponent, then declaring it a triumph of resolve and valour.

The Falklands War wasn't really about the Falklands; it was about Thatcher saving her skin. By 1982, her domestic policies had tanked the economy, and her popularity was scraping the bottom of the barrel. The war provided a convenient distraction, a made-to-order moment of national unity in which even the most disenfranchised Brit was expected to wave a Union Jack and cheer for a victory that did nothing to improve their lives.

Thatcher milked the war for all it was worth, basking in the glow of a "heroic" victory to rebrand herself as a leader of steely resolve. In reality, it was a cynical ploy, an international game of Risk played to keep her premiership afloat while unemployment soared and public services crumbled.

The general mood in Britain during the Falklands War was a toxic stew of nostalgia and denial. The populace, battered by Thatcher's economic policies and facing a bleak future, rallied behind the war effort with the kind of fervour only possible in a country clinging to past glories. It was as though the collective national psyche decided that recapturing a speck of imperial detritus would somehow compensate for the deindustrialization and despair at home.

Critics of the war were shouted down as traitors, because nothing screams "national unity" like ignoring the fact that your country is crumbling while cheering for a pyrrhic victory. For many, the war was a brief reprieve from the grim realities of Thatcher's Britain—a depressing reflection of how little it took to stoke the fires of nationalism in a declining power.

When the dust settled, Britain had spent over £2.8 billion to reclaim a strategic irrelevance. The war cemented Thatcher's political survival but left Britain's reputation as a fading imperial relic intact. The victory was hollow: a brief flicker of international relevance for a nation increasingly viewed as a museum piece on the global stage.

The Falklands War was less about defending sovereignty and more about defending Thatcher's fragile political career. It was a farcical display of overblown patriotism and colonial hubris, a desperate attempt by a fading empire to convince itself—and the world—that it still mattered. Spoiler alert: it didn't.

Margaret Thatcher's legacy did not fade quietly into irrelevance, no matter how much her tear-streaked departure from No. 10 Downing Street might suggest otherwise. Her dramatic resignation, triggered by a party revolt after years of economic vandalism and social fragmentation,

was less a tragic fall from grace and more a karmic reckoning delayed far too long. Yet, to imagine that her influence vanished with her exit would be a grave mistake. Her ideological corpse was barely cold before it was exhumed, reanimated, and polished to a nauseating sheen by none other than Tony Blair and New Labour—a grotesque testament to the staying power of neo-liberalism's self-serving rot.

Blair's rise to power in 1997 marked less of a political shift and more of a rebranding exercise. Thatcher's gospel of neoliberalism—privatisation, deregulation, and the systematic erosion of collective solidarity—was repackaged in shiny sound-bites about modernisation and progress. Blair didn't just inherit Thatcher's play-book; he laminated it and made it required reading.

Massive public spending under New Labour wasn't a reversal of Thatcherite austerity but a Trojan horse for her true passion: public-private partnerships. These schemes, which could be charitably described as "corporate socialism," allowed private companies to leech off taxpayer money while delivering shoddy, overpriced services. Hospitals, schools, and infrastructure were transformed into profit mills, and the public was left footing the bill for decades of debt and decay. Fascism? Perhaps not in the leather-booted, jack-hammer sense, but certainly a close cousin, draped in the bland, smiling veneer of technocratic efficiency.

Thatcher's war on organized labour had already crushed the unions, but Blair ensured their complete burial. The right to collective action, already battered by Thatcher's legislative gauntlet, was further weakened under New Labour, which cosied up to big business and international capital like an overeager debutante at a billionaire's ball. Workers' rights became an afterthought, and the gig economy loomed on the horizon—a grim spectre of precarious employment that Thatcher would have saluted with grim satisfaction.

Ultimately, Margaret Thatcher's government wasn't just a study in cynical governance; it was the operating manual for dismantling a nation. Her policies were a calculated assault on social and economic cohesion, leaving a landscape pockmarked by deindustrialisation, fractured communities, and a triumphant elite drunk on deregulation. She didn't just divide a nation; she atomized it, creating a society where every individual was encouraged to view their neighbour as competition rather than kin.

And what remains of her legacy? A nation that once called itself Great Britain, reduced to a rusting relic haunted by nostalgia for imperial

grandeur and impotent nationalism. Thatcher promised a leaner, meaner Britain; what she delivered was a country hollowed out, staggering on, propped up by the very inequalities she so gleefully entrenched.

Thatcher's tears as she left No. 10 were the only concession to humanity in an otherwise glacial career, though it's unclear whether they were shed for her country or merely her ego. Either way, they were wasted. The damage she wrought was done, and the ideological Pandora's box she pried open has yet to be closed. Her legacy didn't end with a whimper, nor even a bang—it's a toxic fog that continues to choke the life out of a country that once dared to dream of fairness, community, and collective prosperity. And the Iron Lady herself? Rusting, but not forgotten—much to the detriment of everyone.

What is my point, you may ask? Simple: Britain never recovered from Thatcher-ism. Its once-proud national body lies as a rotting, bloated corpse, bobbing on the surface of history's murky waters for all to see—and smell. Every so often, some well-meaning fool slaps on a fresh coat of paint or performs a half-hearted patch-job, as though rearranging the deck chairs on this decrepit Titanic will somehow stop it from sinking. Spoiler alert: it won't.

And nowhere is this national farce more evident than in the spectacle of right-leaning Tories jumping ship to the Reform Party. It's as if they've collectively decided that what Britain needs now is an even purer, uncut strain of the ideological poison that killed it in the first place. These delusional nostalgia jockeys genuinely believe they can resurrect some mythical "glory years"—a fever-dream era that, in reality, never existed outside the pages of propaganda pamphlets and the minds of pundits marinated in gin.

The Reform Party isn't a solution; it's a tantrum in a three-piece suit. It's the political equivalent of a midlife crisis: trading in your rusted-out neo-liberal project for an even flashier, more destructive model. Their promises of "reform" amount to nothing more than doubling down on the same policies that have left the nation staggering like a drunkard in a minefield—deregulation, privatisation, and a healthy dose of misplaced exceptionalism.

If the current trajectory holds, Britain isn't just doomed; it's enthusiastically hurling itself into the abyss while whistling Rule, Britannia! The once-vaunted ship of state is now a ghost vessel, haunted by Thatcher's spectre, captained by a rotating cast of mediocre ideologues, and crewed by a citizenry too disillusioned to mutiny.

The tragedy is that even as the iceberg looms ever closer, Britain's leaders remain steadfast in their suicidal refusal to change course, gripping the wheel like deranged captains on a sinking ship. Enter stage left: the ideologically captured Labour Party, a shambling husk of its original self, now helmed by Sir Keir Starmer—a man whose charisma rivals that of unbuttered toast. Here stands the architect of Britain's adoption of certain Human Rights conventions, whose legacy is a border control turned into a bureaucratic farce at best, and a revolving door at worse. But let's save that particular tirade for another time. For now, suffice it to say that Labour's return to power is not a torch of hope but at best a damp squib in a gale-force storm.

What's worse, Starmer's Labour seems determined to photocopy the failures of the outgoing Biden administration across the Atlantic. But where Biden's brand of ineffectual governance at least comes with the occasional veneer of slick PR and vaguely inspiring sound-bites, Britain's pale imitation manages none of the style, charm, or even basic competence. Instead, we're treated to a political pantomime so devoid of vision it might as well be scripted by algorithms programmed to generate clichés.

This isn't leadership—it's a ghastly pantomime of managerialism, a grim spectacle of dithering technocrats rearranging the rubble of a collapsing nation while claiming they're "building back better." Labour's much-vaunted "change" amounts to little more than recycling the same tired dogma with a slightly more polite tone and performative wokeness to appease their rabid activists.

And the result? A nation caught in an endless cycle of self-inflicted decay, denial, and delusion. From the rotting political class at the top to the disillusioned masses below, Britain lurches forward like a zombie, incapable of reckoning with its decline yet unwilling to take the radical action needed to save itself. No lifeboats, no rescue, just the grim inevitability of a nation quietly sinking under the weight of its own hubris.

Responding To Criticism

Responding To Criticism
Assisted dying is no joke

Following the predictably shallow and self-serving condemnation from both sides of the aisle to my recent article on assisted suicide (which can be found here) I am left with one inescapable conclusion: either I vastly overestimated the intelligence of my readership or catastrophically failed to articulate my point. Given the deluge of reactionary outrage devoid of any substantive engagement, I'm inclined to think the fault lies in the collective inability—or unwillingness—of the audience to grapple with nuanced thought.

Let me clarify, for those too dim or disingenuous to grasp it the first time: my article sought to examine the question currently facing Parliament through the lens of evidence from jurisdictions that have already legislated on this issue, coupled with an analysis of our existing legal frameworks. The aim was to present a balanced, reasoned perspective— an aspiration clearly wasted on a readership more interested in knee-jerk moralizing than intellectual rigour.

Since this effort at subtlety seems to have been spectacularly misunderstood, allow me to spell it out in terms even the most obtuse critic might comprehend: it is my considered opinion that if an individual chooses to end their life—whether due to illness, infirmity, or any other condition—and requires assistance to do so, that decision should rest solely between the individual and their healthcare provider. The government, whose record on handling even the simplest regulatory issues inspires no confidence, has no business meddling in such deeply personal matters. Their sole role should be ensuring that medical regulatory bodies enforce standards of care, not dictating the morality or legality of personal choices.

Furthermore, legislating assisted suicide is a proven recipe for abuse, as evidenced by the slippery slopes in places like Canada and Australia. Both nations have demonstrated how easily such laws can devolve into tools for state overreach and exploitation. To imagine that Britain— especially under the stewardship of a hard-left government composed of frauds, charlatans, and incompetent ideologues—would somehow handle this any better is laughable at best and dangerously naive at worst.

In summary, my stance is simple: the law should decriminalise assistance for those who seek it, full stop. Anything more is an invitation for abuse by a state that has repeatedly shown itself to be neither

compassionate nor competent. If that remains unclear, I suggest some of my critics consider reading beyond headlines and sound-bites before frothing at the mouth.

The Modern World's Origin Myth

How a legacy of death and hate replaced all other origins

The Modern World's Origin Myth
How a legacy of death and hate replaced all other origins

Most civilisations rest on foundations of Origin Myths—grandiose tales that glorify their beginnings, celebrating the heroic birth of a people, their triumph over chaos, and their inexorable march toward greatness. These myths serve as cultural adhesives, uniting disparate individuals under a shared identity, purpose, and pride. But in the smouldering aftermath of the worst slaughter in human history—at that time—something profoundly cynical occurred. The social engineers, those faceless architects of power who pull the strings of humanity's every move, rewrote the rulebook. They dragged humanity's foundational myths out of the sunlight of life and growth and plunged them into the darkness of death, hate, and despair.

Gone were the stories of creation, vitality, and transcendence— narratives that once gave humanity something to aspire to. In their place rose a grim and morbid altar to destruction. The "modern" origin myth became a relentless fixation on the worst of us: our capacity for violence, division, and annihilation. Instead of celebrating the forging of civilisations, this new myth wallows in the ashes of genocide, the trenches of war, and the charred remains of cities.

This shift was no accident. It wasn't the natural evolution of a traumatised species "coming to terms" with its own fragility, as the apologists might claim. No, this was a deliberate act of cultural engineering—a reprogramming of humanity's collective psyche designed to instil guilt, fear, and obedience. After all, a civilization that views its history as an unbroken chain of bloodshed and oppression is far easier to control than one that believes in its own potential for greatness.

World War II has metastasised into the foundational myth of the post-war Western world, a self-congratulatory fable that props up its identity, values, and political structures with a mix of selective memory and moralistic preening. This myth, less history than a carefully manicured narrative, worms its way into cultural memory, policy-making, and public discourse, serving as both shield and sword for the Western order.

The war is immortalised as a grand battle between good and evil, with the Allies nobly wielding democracy, human rights, and freedom against the Axis powers' grotesque fascism and genocide. This oversimplified moral binary conveniently allows the Western world to paint itself as humanity's eternal saviour while ignoring its own hypocrisies. It provides the rhetorical ammunition for institutions like NATO and the UN, which

claim the moral high ground despite often functioning as instruments of self-interest, coercion, or impotence.

The war becomes an epic of collective valour, featuring soldiers, factory workers, and leaders who nobly sacrificed for a just cause. This narrative cloaks the war in a nostalgic haze, sanitizing the brutal realities of internal divisions, imperial exploitation, and racial segregation. By glorifying the sacrifice, it keeps inconvenient truths—like the systemic racism of the U.S. military or the fact that much of the Allied war effort rested on colonial blood and sweat—safely out of focus.

WWII is framed as the crucible that forged unbreakable bonds among Western democracies, setting the stage for cooperation against subsequent bogeymen: communism, terrorism, and whatever else justifies the next war. This kumbaya fantasy ignores the countless fractures within the so-called "unity." Colonial powers held their colonies in an iron grip, and the U.S. busied itself with coups and interventions. The myth, however, justifies NATO's existence and post-war power structures while papering over the profound inequities and rivalries within them.

The Holocaust, rightly condemned as one of history's darkest chapters (if it is true – that's a rabbit hole for another time though), is mythologised as the ultimate warning against hatred and authoritarianism. Western nations brandish "Never Again" as a moral cudgel, even as they cherry-pick where to apply it. Genocides in Rwanda, Bosnia, and elsewhere were met with dithering or indifference. Meanwhile, Holocaust remembrance often sidelines uncomfortable truths that Jews weren't the only people who suffered but the Zionist regime out of the modern state of Israel use it as a cultural bludgeon to uphold their own systems of racial oppression.

The war is celebrated as the engine of modern progress, supposedly proving the resilience of capitalist democracies through innovation and post-war rebuilding. This narrative glosses over the obscene destruction that necessitated rebuilding in the first place. It conveniently credits the Marshall Plan while ignoring the pillaging of defeated nations, the exploitation of the "Global South" as it has become known, and the Soviet Union's remarkable recovery—a feat achieved without the West's self-congratulatory financial interventions.

The U.S. emerges as the benevolent architect of the post-war world, liberating the oppressed and spreading democracy as "the leader of the

free world." This self-aggrandising myth disguises American hegemony as altruism. The U.S. didn't just liberate—it bombed, manipulated, and overthrew to secure its interests. This narrative sanctifies its interventions, whether in Vietnam, Iraq, or beyond, as extensions of the WWII legacy, no matter how self-serving or disastrous.

The Western WWII myth is a masterpiece of omission. It relegates the Soviet Union's massive, decisive sacrifices to the margins, lest the credit go anywhere but the West. It erases colonised peoples' contributions and suffering, as though Britain and France won the war without the millions of Indian, African, and Southeast Asian troops they conscripted. It forgets that the Allies themselves upheld brutal systems of segregation, apartheid, and imperial domination.

As an origin myth, WWII is a towering edifice of half-truths and omissions, designed to fortify the West's moral and political supremacy. It demands reverence while eliding its inconvenient complexities, ensuring that history remains a pliable tool for justifying the status quo. Like all myths, it tells us more about the present than the past: a world desperate for self-justification and riddled with contradictions it refuses to confront.

This is all with a cause however. Allow me to explain.

The social engineers took the raw materials of human suffering— millions dead, untold atrocities, the obliteration of entire cities—and transmuted them into a new moral framework. They didn't just rewrite the history books; they rewired the way we see ourselves. Humanity became not the architects of its destiny but the custodians of its sins, forever burdened by the spectre of its worst moments. In this bleak narrative, modernity was no longer the culmination of human ingenuity and resilience but a fragile house of cards, one gust of human fallibility away from collapse.

The new mythology exalts death as its defining feature. The vast cemeteries of war became its sacred spaces, the Holocaust its unassailable cornerstone. The message was clear: Never forget—not because remembering offers redemption, but because it keeps the spectre of our collective guilt alive. Every cultural milestone, every innovation, every act of progress is forced to pass through the filter of this

macabre origin story. The implication is that humanity has no future worth envisioning unless it wallows in the sins of its past.

At the heart of this grim mythology lies the elevation of hate and despair as the dominant forces shaping history. Hate—whether racial, political or ideological—is presented not as a failure of human systems but as their default setting. Despair, meanwhile, is celebrated as the only reasonable response to our past, ensuring that hope remains a rare and fleeting commodity.

This mythology has rendered humanity docile. A people taught to see themselves as the inevitable perpetrators of atrocities are far less likely to challenge authority. Fear of repeating history becomes a leash; despair over humanity's inherent flaws becomes a cage. And so the architects of this narrative consolidate their control, unchallenged by a species too paralysed by its self-loathing to imagine a better way.

What the social engineers have built is not a mythology but an anti-mythology—a twisted inversion of the stories that once uplifted and unified civilisations. It is a monument not to human potential but to human failure, a testament to their belief that humanity must be ruled, shaped, and constrained lest it destroy itself. And the crowning irony? They've convinced us to worship this edifice of despair as though it were sacred, to genuflect before our collective guilt as though it were redemptive.

By abandoning myths of life, growth, and transcendence, humanity has lost its sense of purpose. We no longer build toward a shining ideal; we merely scramble to avoid another catastrophe. Our imaginations, once capable of envisioning utopias, now churn out dystopias by default. And the true tragedy? The architects of this new myth knew exactly what they were doing. They traded humanity's aspirations for their own dominance, and we've been thanking them for it ever since.

This is not progress. It's a profound act of theft—a robbery of humanity's birthright to dream, to grow, and to create. And until we reclaim the stories of our beginnings, we will remain trapped in the narrative of our own destruction, pawns in a game we've been conditioned to believe we deserve to lose.

The Real Horror of Labour Begins

A vision of hell swims into view.

The Real Horror of Labour Begins

A vision of hell swims into view.

As much as I loathe to admit it, We were once a bastion of liberal democracy and individual rights. However, the United Kingdom now serves as the most morbidly fascinating proof of Yuri Bezmenov's grim warnings. Bezmenov, a Soviet defector turned ideological Cassandra, explained the KGB's blueprint for ideological subversion in four chillingly methodical stages: Demoralisation, Destabilisation, Crisis, and finally, the velvet hammer of Normalisation. Britain, it seems, has not only walked every step of this macabre path but done so with an enthusiasm bordering on masochism.

The first stage, Demoralisation, requires a mere 15–20 years—enough time to churn out a single generation steeped in self-loathing and resentment for its own civilization. Britain has excelled at this. Decades of indoctrination in classrooms have rebranded national pride as bigotry and cultural heritage as a collection of sins. Intersectionality, that grimly efficient ideological cudgel, has forged a generation taught to measure morality by the yardstick of victimhood.

What follows demoralisation is destabilisation—rapid, divisive, and almost laughably predictable. The UK, once bound by a shared sense of identity, now teeters on the brink of cultural schism. The politics of the Friend/Enemy distinction have been institutionalised, with grievance-mongers from every conceivable corner tearing at the seams of social cohesion. The result? Fragmentation so profound that even basic tenets of liberal democracy—free speech, the rule of law, equal treatment—are now controversial.

And so, inevitably, we arrive at Crisis, the third act in Bezmenov's tragedy. Here, Britain's government reveals itself not as the arbiter of the people's will, but as the obedient servant of its new masters—whether they be Islamist networks or the ideologues of neo-Marxist thought. A detailed exposé by Connor Tomlinson has laid bare the rot within the Home Office, particularly its insidious Research, Information, and Communications Unit (RICU).

This shadowy department oversees propaganda campaigns so brazen that even Orwell might blanch. Post-terrorism PR strategies urging victims' families to suppress righteous anger? Check. Resources squandered on dismissing grooming gang scandals as "right-wing grievance narratives"? Of course. Prevent referrals that prioritize flagging

readers of The Lord of the Rings over those harbouring actual jihadist sympathies? Naturally.

What remains is Normalisation, the most chilling stage, where absurdity becomes orthodoxy and dissent is pathologised. RICU's recent report paints a grim picture of this "new normal." Cultural nationalism—a benign belief in preserving Western heritage—is now deemed "extreme right-wing." The ideological capture is so complete that references to Beowulf and C.S. Lewis appear in the same breath as neo-Nazism, while the Qur'an and Hadiths, sources of ideological justification for many terror attacks, are notably absent from scrutiny.

The Prevent programme, ostensibly a counter-extremism initiative, epitomises the UK's suicidal priorities. The case of Ali Harbi Ali, who murdered MP Sir David Amess, underscores the catastrophic negligence at play. Despite a clear early warning, Prevent dismissed him with bureaucratic indifference. Meanwhile, its staff were busy cataloguing children's literature as extremist fodder. If this isn't the moral bankruptcy of the state, then words have lost their meaning.

A key figure in this dismal farce is Keir Starmer, a man whose professional history reads like a greatest-hits compilation of enabling the very people intent on dismantling the society he ostensibly serves.

Back in 2008, during his tenure as Director of Public Prosecutions, Starmer took it upon himself to represent the interests of Hizb ut-Tahrir at the European Court of Human Rights, a decision couched in the banal pieties of "representation" and "justice for all." Never mind that this particular group, whose stated goals include establishing a global caliphate and waging ideological warfare against the West, was already the subject of damning scrutiny. William Shawcross's report highlights Hizb ut-Tahrir as a malign influence undermining counter-extremism initiatives like Prevent.

Shawcross noted that the group's propaganda framed the state's efforts to curb Islamist extremism as an attack on Islam itself—a line that has since become gospel for every grievance-mongering activist with a passing interest in rhetorical gymnastics. The organisation's influence within law enforcement, via intermediaries like the National Association of Muslim Police (NAMP), further ensured that terms like "jihadism" and "Islamism" were deemed too inflammatory for official use. This linguistic contortion-ism, of course, coincided with the group actively campaigning against measures aimed at rooting out terrorism.

The Metropolitan Police, in a truly Kafkaesque twist, responded to Hizb ut-Tahrir's open calls for jihad after October 7th with a hand-wringing explanation about the "multiple meanings" of the word. This was after their erstwhile advisor Mohammed Kozbar—he of "Hamas are the master of the martyrs" fame—was found lauding the group. Starmer's involvement with Hizb ut-Tahrir, whether born of naivety or ideological sympathy, served as an early prologue to his career-long pattern of representing the indefensible.

As a barrister, Starmer gleefully exercised the "cab rank" rule to justify championing clients whose collective rap sheet includes terrorism, murder, and incitement. From blocking the extradition of Abu Hamza's acolytes to shielding the associate of a Taliban assassin, Starmer's caseload reads like the FBI's most-wanted list reimagined as LinkedIn endorsements. His curriculum vitae even extends to securing reduced restrictions for jihadists caught with weapons and thwarting deportations of men deemed too dangerous to remain in Britain.

Then there's his pro bono work, a phrase that in Starmer's case might as well translate to "ideological moonlighting." Representing Nation of Islam leader Louis Farrakhan was apparently no moral quandary for the future Labour leader. Nor was consulting on the defence of Zacarias Moussaoui, the infamous "20th hijacker" of 9/11, or cosying up to apologists for Guantanamo detainees with ties to mass murder. Starmer's legal CV appears to be a love letter to every enemy of Western civilization, penned with the flourish of someone utterly detached from the consequences of his actions.

The real masterpiece, though, lies in the eerie synchronicity between Starmer's courtroom exploits and the wider decay of Britain's institutional resolve. Starmer may plead professional obligation, but his track record suggests something far bleaker: an uncanny talent for advancing the interests of those who would see the very fabric of liberal democracy shredded to ribbons.

Keir Starmer, the man who would be Prime Minister, wears his ideology as subtly as a neon sandwich board reading "Lifelong Communist." His recent self-declaration as a socialist is hardly breaking news; it's a belated confession to a political faith evident in every stage of his career. But let's not take him at his word—let's dig.

Starmer has been a proud adherent of Pabloism since his twenties, a strand of socialism so esoteric and performatively radical that even garden-variety leftists might blush. In a 2020 interview with the New

Statesman, Starmer admitted he hasn't wavered from the core issues that captivated him in his youth: gender activism, environmentalism, and the endless fracturing of identity politics. These "incredibly exciting" movements, to borrow his words, were the perfect scaffolding for his vision of a fractured, resentful utopia.

The man joined the Haldane Society of Socialist Lawyers in 1986—a group so committed to the leftist cause they practically draft their pleadings in red ink. He remained with them for over two decades, stepping away only when his career demanded the veneer of impartiality as Director of Public Prosecutions.

Starmer's extracurricular activities weren't exactly subtle either. In 1986, he toddled off to a Czechoslovakian work camp to "restore a Nazi atrocity memorial"—a trip that, coincidentally, landed his name in the files of the Czechoslovakian secret police. And let's not forget his jaunt to Moscow and St. Petersburg in 1991, conveniently timed to witness the Soviet Union's swan song. These aren't the hobbies of a dispassionate legal mind; they're the scrapbook of a man deeply enmeshed in the machinery of the radical left.

And then there's his Chancellor, Rachel Reeves, who's taken Starmer's communist chic to new heights. Hanging a portrait of "Red Ellen" Wilkinson in Number 11, Reeves symbolically ousted Thatcher's Chancellor Nigel Lawson—a perfect encapsulation of Labour's ideological priorities. It's no coincidence that Reeves' Halloween Budget delivered a Stalinist trick to Britain's farmers that recalls the horrors inflicted on the Kulacks, wrapped in the thin veneer of progressive reform.

This supposed "inheritance tax raid on the wealthy" is, in reality, a full-scale assault on Britain's small family farms. Using outdated property valuations, the Treasury low-balled its estimates, claiming only 500 estates per year would be affected. The real figure? Around 70,000, according to DEFRA's own farm business survey figures. Yet Reeves' Treasury has conveniently delayed an official assessment until mere months before the tax takes effect—a Machiavellian mix of obfuscation and procrastination.

When challenged, the Labour spin machine went into overdrive. The BBC's so-called Verify service regurgitated talking points from Dan Neidle, a supposed "independent" tax expert with clear Labour ties. Neidle dismissed more accurate estimates as "hyperbolic fake stats," while his own revised calculations quietly admitted that Reeves' policy misses its ostensible targets entirely. The mega-rich remain untouched,

while ordinary farmers are left to foot the bill for a policy designed to punish them for their existence.

It doesn't take a crystal ball to see where this is heading. Labour's land grab is a thinly veiled attempt to re-engineer rural Britain into a state-controlled serfdom. Farmers are too independent, too conservative, too... inconvenient. Better to dismantle their livelihoods under the guise of "progress."

This is no accident. The intellectual underpinnings of Labour's policy are dripping with Marxist contempt for private property and inherited wealth. Former Blair advisor John McTernan went so far as to declare that small farming is "an industry we could do without," channelling the cold disdain of a Soviet commissar discussing kulaks. Meanwhile, Labour-friendly columnists like Will Hutton wrap their redistributive fantasies in the language of market reform, calling inheritance tax a "life tax on undeserved good luck." Strip away the euphemisms, and it's clear: Labour isn't interested in reform. They want revolution by stealth.

The echoes of Soviet policy are deafening. Demonise the countryside as reactionary and backward. Seize the means of production—or in this case, the farmland. Use the machinery of state to enforce a joyless, homogenised equality that leaves everyone poorer. This isn't policy; it's punishment for the cardinal sin of being self-sufficient and unaligned with Labour's urban elite.

Britain is edging closer to becoming a Potemkin democracy, where ideological conformity is enforced with the same ruthless efficiency as it was in the Eastern Bloc. Labour's land tax is just the beginning—a down payment on a future where dissent is costly, independence is outlawed, and the countryside is re-engineered into a socialist utopia.

To Boldy NO!!!

A Fanboy's Thesis

To Boldly No!!!

A Fanboy's Thesis

Let's talk about The Cage, the original pilot episode of Star Trek, an artefact of TV history that is, despite its rejection, nothing short of a masterpiece. I'll say it outright: "The Cage" is not just good—it's probably the best episode of The Original Series. Yes, The Cage, that grim, contemplative gem about Captain Pike, the pre-Kirk Enterprise, and the unflattering truths of the human condition. If you're unfamiliar, the plot is deceptively simple: a distress call lures Pike and his crew to a long-lost colony ship, only for it all to unravel as an elaborate trap by aliens who want to add Pike to their grotesque menagerie. What follows is a surprisingly profound meditation on captivity, free will, and the indomitable human spirit. And yet, the network didn't bite. The adventures of Captain Pike were dead on arrival.

Cue the revisionist mythos of Star Trek fandom. The usual story, handed down like gospel at conventions and Reddit threads, goes like this: the network dismissed "The Cage" as "too cerebral" for American audiences, who—bless their dim little hearts—allegedly couldn't handle a sci-fi plot with more nuance than a fistfight with a rubber-suited alien. But lo, thanks to Lucille Ball's divine intervention, Gene Roddenberry got a second chance with "Where No Man Has Gone Before," and the rest is history. Except it isn't.

Let's be clear: the idea that "The Cage" was rejected purely for being too smart is fandom bunkum. A nice yarn to make Star Trek feel like the misunderstood genius of 1960s television, but a myth nonetheless. The real reason for its rejection? Censorship. Specifically, that scene—the one with the infamous Orion Slave Girl. Ah yes, the scene that introduced mid-century America to the sight of Susan Oliver painted green and writhing seductively in what might generously be called an outfit.

Now, let me pre-empt the inevitable screeching: "But they hated Number One! The strong female character was too much for the network suits!" To which I say: rubbish. Don't kid yourself. The real problem wasn't Majel Barrett's deadpan competence; it was William Ware Theiss and his insidious genius.

Enter the Theiss Titillation Theory, a delightfully cynical encapsulation of how mid-century TV kept viewers glued to their sets while tiptoeing around moral outrage. William Ware Theiss, Star Trek's costume designer, didn't just dress characters—he weaponized fabric. His

signature style? Outfits that somehow revealed everything and nothing, clinging improbably to key areas while leaving just enough to the imagination. The Orion Slave Girl's ensemble was his crowning achievement: a costume that danced right up to the edge of decency and dared the censors to flinch. And flinch they did.

Theiss's work wasn't about high art or narrative fidelity; it was about ratings. He understood the grubby truth about TV audiences: they wanted the illusion of danger, the tease of the forbidden, but never the outright scandal of actual exposure. It's a sly commentary on human nature—our hypocritical appetite for titillation wrapped in a veneer of moral superiority. By today's standards, the Orion scene is laughably tame, but in 1964, it was a step too far for network executives petrified of letters from outraged church groups.

So, "The Cage" didn't fail because it was too clever for the masses or because the patriarchy couldn't handle a woman on the bridge. It failed because mid-century American TV was obsessed with a prim, buttoned-up society that demanded entertainment sanitise its deepest, dirtiest impulses. Theiss's costumes, for all their ingenuity, were just one step too bold for a world that wanted to peek through the curtain without pulling it back. And thus, Star Trek would have to wait until 1966 to boldly go where it had been told, quite firmly, not to go before.

Unworthy In The Extreme

The case against Sadiq Khan

Unworthy in the Extreme
The case against Sadiq Khan

Sadiq Khan, London's perpetually grinning mayor and self-anointed saviour of progressive politics, has presided over a city teetering on the brink of dystopian collapse. This is a man who casually suggested that terrorism is "part and parcel" of life in a modern metropolis—a statement so blasé it could double as a recruitment slogan for nihilism. Now, as whispers of a potential knighthood in the New Year's Honours list circulate, one might wonder if the British honours system is being curated by satirists rather than statesmen. Surely, if anything underscores the death of meritocracy and the rise of ideological back-patting, it's this grim jest.

But for those who've been living under a rock—perhaps one blessedly distant from Khan's chaotic kingdom—let's embark on a guided tour of his most glaring "achievements." Each one is a monument to mediocrity, ineptitude, and the triumph of optics over outcomes:

Crime Under Khan: London's Descent into Urban Carnage

Under Sadiq Khan's illustrious leadership, London's streets have morphed into something out of a dystopian gladiatorial arena, where survival is less about community spirit and more about dodging knife-wielding assailants. Knife crime has surged, violent crime has skyrocketed, and the perpetrators seem to treat the city as their personal coliseum, knowing full well that their chances of facing consequences are slim to none.

Khan, of course, responds to this carnage with his signature move: a feeble shrug and a steady stream of vapid sound-bites about "community cohesion" and "root causes." He convenes summits, chairs meetings, and hosts workshops—none of which seem to involve actually getting knives off the streets or making Londoners feel safe.

Statistics paint a damning picture. Homicides under Khan have consistently remained higher than when he took office, with 2021 seeing the worst-ever annual toll of teenage killings.

Knife crime surged by 60% in his first term alone, and robberies soared by a jaw-dropping 86%. Yet, instead of taking decisive action, Khan slashed police budgets during a pandemic when crime rates were already spiralling, blaming austerity and everything but his own leadership.

81

Londoners, meanwhile, live in fear. The law-abiding cower behind locked doors, while the criminals roam with impunity, emboldened by the lack of visible policing and the knowledge that Khan's administration would rather focus on "reform" than actual enforcement. Stop-and-search policies, once a contentious but effective tool, have been watered down under his watch, rendering them more symbolic than functional.

Rather than delivering solutions, Khan offers distractions. When violent crime stats spike, he shifts the conversation to peripheral issues or blames external factors, refusing to acknowledge that his leadership has exacerbated London's descent into lawlessness. Crime in Khan's London isn't just a statistic—it's a lifestyle choice for those brazen enough to seize the opportunity created by his ineffectual governance.

In Sadiq Khan's London, the message is clear: criminals are emboldened, victims are forgotten, and leadership is a spectator sport. The result? A city that feels less like a beacon of civilisation and more like the Wild West with better PR.

Housing Under Khan: A Crisis Repackaged as Progress

London's housing crisis, already a simmering catastrophe, has exploded into absurdity under Sadiq Khan's stewardship. His grand promises of affordable housing have proven as tangible as fairy dust and as likely to appear as unicorns galloping down Oxford Street. With every passing year, Khan sets lofty targets only to spectacularly miss them, leaving Londoners drowning in rent payments while property developers pop champagne on penthouse balconies.

In 2016, Khan pledged to deliver 116,000 affordable homes by 2022—a figure so ambitious it might as well have been plucked from the pages of a fantasy novel. By the halfway mark of his term, he had managed a pitiful 12,000 completions.

The affordable housing Khan does tout is often anything but; with developers exploiting loose definitions and loopholes, these so-called "affordable" units remain out of reach for average Londoners.

Meanwhile, luxury developments mushroom across the skyline, their vacant units serving as investment assets for oligarchs rather than homes for actual residents. The property market under Khan has become a playground for global capital, while those who live and work in the city are priced out or crammed into substandard accommodations. His administration's response? More press releases and glossy campaigns that do little to address the root causes of the crisis.

82

Khan blames government austerity and funding shortfalls, yet his own mismanagement and inability to hold developers accountable have exacerbated the situation. His deals with developers often favor profit over people, allowing them to sidestep affordable housing quotas through token contributions or meaningless promises. The result is a city where cranes dominate the skyline, building homes that no one can afford.

In true Khan fashion, the rhetoric doesn't match the reality. He touts his housing "achievements" at every opportunity, conveniently ignoring the rising homelessness rates, skyrocketing rents, and gentrification that push long-standing communities out of their neighbourhoods. His tenure has turned London into a case study in urban inequality: a glittering metropolis for the wealthy, and an impossible labyrinth for everyone else.

The housing crisis under Khan isn't just a failure of policy—it's a betrayal of Londoners. While he poses for photo ops at new developments, the very people he claims to represent are left to fight for scraps in a market rigged against them.

Transport Under Khan: A Journey to Nowhere

Sadiq Khan's approach to London's transport system is a case study in performative governance. The man can't resist a photo-op next to a gleaming electric bus, grinning as though he personally welded it together. Yet behind the Instagram-ready façade, Transport for London (TfL) has been lurching from one financial disaster to the next, with fare hikes, delays, and inefficiencies becoming the grim norm.

TfL's finances under Khan are less a train wreck and more a catastrophic derailment. The organization has been teetering on the brink of insolvency for years, requiring multiple government bailouts just to keep the lights on. Khan blames the pandemic and government austerity, but TfL's woes are deeply rooted in his own mismanagement. Fare freezes—a headline-grabbing promise that only applied to single fares, not travel-cards or daily caps—have done little to offset the spiraling costs.

Meanwhile, Khan has poured vast sums into his pet projects, including his beloved cycling lanes and Low Traffic Neighbourhoods (LTNs). In theory, these schemes should reduce emissions and encourage sustainable transport. In practice, they've created clogged roads, displaced traffic into residential areas, and hammered local businesses dependent on vehicle access. For every cyclist enjoying a leisurely ride down a pristine cycle lane, there's a delivery driver stuck in gridlock and a shopkeeper staring at empty tills

Crossrail, the much-vaunted addition to London's transport infrastructure, was supposed to be a feather in Khan's cap. Instead, it became an emblem of delays and overspending, opening years late and billions over budget. While he's quick to trumpet its eventual completion as a victory, the project's failures speak volumes about the systemic inefficiency under his tenure.

All the while, commuters are squeezed ever harder. Fare increases hit pockets year after year, even as service reliability plummets. Delayed trains, crammed buses, and station closures are the reality for Londoners, while Khan pats himself on the back for painting more cycle lanes and installing ULEZ cameras.

In Khan's London, transport isn't about efficiency or accessibility—it's a platform for vanity projects and virtue signalling. The result? A city where getting from A to B feels like navigating a never-ending obstacle course, with the added insult of being charged more for the privilege. TfL may be his jurisdiction, but under Khan's leadership, it's everyone else who pays the price.

ULEZ Expansion: A Masterclass in Bureaucratic Extortion

Sadiq Khan's Ultra Low Emission Zone (ULEZ) expansion, heralded as his environmental "crown jewel," feels more like a thinly veiled cash grab designed to fleece Londoners under the guise of ecological virtue. While Khan pontificates about cleaner air and saving lives, the actual implementation of this policy has sparked outrage, disproportionately punishing small businesses and low-income families already teetering on the edge of economic survival.

Expanding ULEZ into outer boroughs has turned vast swathes of London into a dystopian landscape of surveillance cameras and punitive fines. Small businesses reliant on older vehicles have been blind-sided, forced to either shoulder the crippling costs of upgrading fleets or face daily charges that erode profits. For many, it's not just an inconvenience —it's an existential threat. Tradespeople, delivery drivers, and family-run shops have found themselves squeezed to the brink, casualties of a policy seemingly crafted without the faintest understanding of economic reality.

And then there's the impact on ordinary Londoners. Families struggling to make ends meet now face hefty penalties simply for driving to work or ferrying their kids to school. For those in outer boroughs, where public transport is patchy at best, the expanded ULEZ feels like an extortion

racket—pay up or stay home. The scheme hits the poorest the hardest, all while Khan touts it as a progressive triumph.

Of course, the environmental benefits Khan champions are not only debatable but also laughably undermined by his administration's own policies. With Heathrow expansion plans quietly advancing and no serious moves to tackle aviation emissions—the single largest source of air pollution in the city—the ULEZ begins to look less like a green initiative and more like a cynical revenue generator targeting those least able to fight back.

This isn't policy—it's punishment. Under Khan's ULEZ, the air might be a fraction cleaner, but the cost to livelihoods and the social fabric of London is staggering. It's a testament to his priorities: a city squeezed dry to fund his vanity projects while its residents are left to bear the brunt. The expansion of ULEZ doesn't represent progress; it's a monument to a mayor who governs with one eye on his legacy and the other firmly shut to the consequences.

Policing Under Khan: A Masterclass in Absentee Leadership

The Metropolitan Police under Sadiq Khan's tenure has been an unmitigated disaster, defined by scandal, incompetence, and a spectacular collapse in public confidence. Once viewed as a cornerstone of safety and justice, the Met has devolved into a punchline for late-night jokes and a lightning rod for public outrage. Mismanagement, toxic culture scandals, and a glaring lack of accountability have left Londoners questioning whether their protectors are capable—or even willing—to uphold the law.

Khan's leadership, if you can call it that, has been conspicuously absent when the Met needed it most. Institutional racism, misogyny, and corruption scandals have rocked the force repeatedly, most infamously with cases like Sarah Everard's murder by a serving officer and the appalling revelations of institutional misconduct within the force.

Khan's response? Publicly wringing his hands while dodging any meaningful responsibility. He's quick to call for "culture change" and even quicker to shuffle blame onto everyone but himself.

But while London's streets descend into chaos, the Met seems to have redirected its energy to loftier pursuits—namely, policing social media. Officers spend their time monitoring tweets, doling out warnings for offensive memes, and issuing fines for politically incorrect Facebook posts. Meanwhile, knife crime, burglaries, and assaults skyrocket as

criminals take full advantage of a force more interested in hashtags than handcuffs.

Under Khan, resources have been slashed, morale has plummeted, and the very people tasked with protecting Londoners have been left adrift in a sea of bureaucratic ineptitude. His sacking of Dame Cressida Dick was less a move of decisive leadership and more a desperate attempt to save face—a hollow gesture in an otherwise vacuous tenure.

The result? A police force more embroiled in scandal than solving crime, a mayor more interested in optics than outcomes, and a city where the rule of law feels like a distant memory. Policing under Khan is emblematic of his leadership: all talk, no action, and a growing sense that the people of London have been left to fend for themselves.

Economic Decline: London Under Khan—A Case Study in Squandered Potential

London, once the beating heart of global commerce and culture, has steadily dimmed under the interminable tenure of Sadiq Khan. The city's vibrancy and dynamism, hallmarks of its status as a global hub, now feel like relics of a bygone era. Thanks to Khan's uninspired economic policies and endless tinkering with bureaucracy, the capital feels less like an economic powerhouse and more like a sluggish backwater, stuck in the mud while the rest of the world speeds ahead.

Crippling business rates and a lack of meaningful reform have made operating in London a game of survival for small and medium enterprises. Khan has repeatedly bemoaned the cost-of-living crisis and its impact on businesses, yet his administration has done little beyond issuing platitudes and vague assurances. Meanwhile, once-thriving high streets now resemble ghost towns, as shops shutter their doors under the weight of exorbitant rents, astronomical taxes, and dwindling foot traffic.

Khan's pandemic recovery policies were equally lacklustre. His response to one of the greatest economic upheavals in living memory was as uninspired as it was ineffective. Businesses cried out for targeted support, streamlined regulations, and innovative recovery strategies. What they got instead were vague pronouncements and piecemeal initiatives that barely scratched the surface. Entire sectors, from hospitality to retail, were left to fend for themselves as Khan's administration prioritized optics over actual outcomes.

Even London's famed global appeal as a hub for talent and innovation has suffered under his watch. A toxic combination of soaring living costs,

housing shortages, and declining infrastructure has driven talent elsewhere, while investment has stagnated. Once a beacon for entrepreneurs, London now feels like an unwelcoming labyrinth, its potential squandered under a mayor who seems more concerned with Twitter battles than tackling real-world challenges.

Sadiq Khan's tenure has been a masterclass in mediocrity, turning one of the world's most dynamic cities into a case study in squandered opportunities. Businesses falter, innovation stagnates, and economic vibrancy fades—all while Khan continues his relentless campaign of self-congratulation, blissfully oblivious to the economic decline unfurling under his watch. If London was once a city that never stopped, under Khan, it feels like it's stuck in neutral—its wheels spinning, but going nowhere fast.

Cultural Decay Under Khan: The Erosion of London's Soul

Under Sadiq Khan's reign, London has transformed into a grotesque parody of its former self: a bifurcated urban nightmare where, on one side, wealth flows like champagne, and on the other, desperation reeks like the rubbish left uncollected in decaying council estates. Half of London feels like a sanitised corporate dystopia, devoid of character or charm, while the other half teeters on the edge of chaos—so dire that even those fleeing global crises might think twice before calling it home.

The death knell for London's cultural vibrancy rings loudest in the closures of small, independent venues—once the lifeblood of the city's creative spirit. In their place rise soulless high-rises and identical chain stores, creating a mono-cultural wasteland catering to the bland tastes of hedge-fund expats and Airbnb tourists. The neighbourhoods that birthed global art movements and subcultures now resemble an open-air museum curated by developers with all the artistic sensitivity of a bulldozer.

Khan's much-trumpeted diversity initiatives do little to counteract this cultural sterilisation. They often feel more like performative box-ticking exercises than genuine efforts to uplift marginalized communities. Glossy marketing campaigns proclaim London as a beacon of inclusivity, while the actual beneficiaries of these initiatives remain elusive. Communities that could thrive with investment instead face gentrification, displacement, or neglect, their struggles buried beneath layers of politically correct PR.

This is a city where public art installations are funded to score virtue points, while grass-roots art spaces—the places where real culture is

created—are priced out of existence. Khan's administration seems more interested in curating Instagrammable spectacles for tourists than fostering the authentic, gritty creativity that made London a cultural capital in the first place.

In the end, what's left is a hollowed-out metropolis, where the idea of diversity is co-opted to distract from the very real homogenisation of its landscape. London has become a place where the rich grow richer, the poor grow desperate, and the city's once-vibrant soul fades into obscurity —a eulogy to what happens when governance prioritizes optics over people.

Grandstanding: The Khan Legacy of Hollow Self-Promotion

Sadiq Khan's political play-book seems to be ripped straight from the "all PR, no substance" handbook. Whether it's sparring with Donald Trump on Twitter—a global audience clapping for the banter while London burns— or delivering yet another self-congratulatory speech about his so-called "achievements," Khan has mastered the art of saying a lot while accomplishing little. His PR machine churns out glossy narratives with the intensity of a tabloid newsroom, but dig beneath the surface, and you'll find little more than hot air.

When Londoners face tangible crises—soaring crime, a spiralling housing disaster, or economic stagnation—Khan's solution is almost always a photo-op, an empty sound-bite, or a contrived clash with a convenient villain. His very public spats with Trump were less about principle and more about building his personal brand, offering distraction from the failures piling up back home. It's the political equivalent of setting fire to your kitchen but inviting the neighbours to watch you extinguish a bonfire in the garden.

The mayor's speeches, meanwhile, are triumphs of self-promotion wrapped in empty platitudes. Khan speaks of "making history" and "transforming London," conveniently ignoring the glaring evidence of decline in almost every measurable category. He loves a podium but avoids accountability like the plague. Actual governance is relegated to a distant second priority behind maintaining his carefully crafted public persona.

His relentless self-marketing would be almost admirable if it weren't so transparently hollow. Khan's campaigns are big on buzzwords but devoid of depth. "Community," "equality," and "opportunity" are trotted out like magic spells meant to distract from the realities Londoners face: spiralling

crime rates, sky-high rents, and businesses on life support. And let's not forget his insatiable thirst for photo opportunities, where every ribbon-cutting and policy announcement is treated like the second coming of political genius.

The result? A mayor who excels at being visible but is conspicuously absent when it comes to actual leadership. For Khan, substance isn't just rare—it's an afterthought. His tenure has been one long PR exercise, with London as the unfortunate backdrop for his self-aggrandizing theatrics.

In Summary: Khan's Legacy of Hubris, Mediocrity, and Irrelevant Grandstanding

Sadiq Khan's tenure as Mayor of London has been a stunning cocktail of hubris, mediocrity, and ineffectual governance. His time in office has transformed London from a global powerhouse into a city marred by stagnation, neglect, and self-congratulatory rhetoric. London deserves so much more than the hollow political performance Khan has offered. The city's residents are left to navigate the worsening realities of crime, unaffordable housing, and a fractured economy, while Khan obsesses over his public image and high-profile photo ops. In fact, his fixation on self-promotion and distraction politics has come at the expense of real leadership.

At the heart of Khan's failure is a staggering lack of substance. His promises of affordable housing remain largely unfulfilled, while his so-called "green" initiatives—like the ULEZ expansion—are little more than thinly veiled cash grabs that harm small businesses and working-class Londoners.

Meanwhile, his repeated failures to address rampant crime and an increasingly strained public transport system have only made Londoners feel more vulnerable and neglected.

His PR machine, relentless and polished, continues to pump out talking points about "change" and "progress," but the actual impact of his governance is deeply lacking. Khan's approach to London's challenges seems to have been one of avoiding difficult decisions and instead opting for politically expedient measures that gain him headlines but do little to solve the problems his constituents face on a daily basis.

When the city needed a mayor to tackle deep-rooted issues, Khan responded with grandstanding and virtue signalling, presiding over a leadership vacuum that allowed problems to fester unchecked. He spends more time fighting Twitter wars and pushing irrelevant cultural

agendas than he does focusing on what really matters: fixing London's broken housing market, ensuring the safety of its residents, and reviving its stagnant economy.

In short, Khan's legacy is one of squandered opportunity—a mayor more concerned with polishing his public image than delivering real solutions for the city he's meant to serve. London deserves a leader who prioritizes action over self-promotion, but under Khan, it seems doomed to continue its slow spiral into irrelevance.

BE WELL

An Appraisal of Demolition Man

Dystopian Literature for the Silver Screen

OBLIVIONMEDIA.SUBSTACK.COM

DEMOLITION MAN

An Appraisal of Demolition Man
Dystopian Literature for the Silver Screen

The 1993 film Demolition Man is a strangely prescient nugget of gloriously brain-dead action, drenched in explosions and wrapped in a neat foil of cultural critique. It offers mass surveillance, contactless greetings, and a regime of compulsory politeness that makes Orwell's nightmares look like amateur hour. The story begins in the futuristic dystopia of 1996 Los Angeles—amusingly more liveable than the actual 2024 Los Angeles, though that's a low bar limboed beneath by a city currently infested with the consequences of unchecked "progress."

But let's not dwell too much on how this film accidentally became a crystal ball for our time. What makes it fascinating is how it shamelessly grapples with the bones of dystopian literature while guzzling from a bottle of neat, high proof 90s action schlock. Yes, it nods to Aldous Huxley's Brave New World—not just with a wink, but a sledgehammer—but it's no lazy knock-off. Beneath the ka-booms and cheesy one-liners, there's something genuinely thought-provoking, even if it has to elbow its way past Stallone's biceps to get there.

The movie kicks off in 1996 with "super cop" John Spartan dramatically rappelling into a gang compound to rescue hostages from Simon Phoenix, a villain so cartoonish he makes Snidely Whiplash look nuanced. Naturally, the whole place explodes in a fireball worthy of Michael Bay's wettest dreams. C4 ignites from a "gas fire," because that's definitely how science works. Phoenix gets arrested for his evil shenanigans, but when the hostages' bodies are found, Spartan is conveniently railroaded into prison faster than you can say "plot device."

Welcome to cryo-prison, where criminals are flash-frozen into icicles while the system reprograms their brains with "rehabilitative" skills. Rehabilitation, of course, being code for state-sanctioned brainwashing.

Fast-forward to 2032, where Simon Phoenix is thawed out like last night's dinner for a parole hearing. Shockingly, he breaks free and begins terrorizing San Angeles, a utopian hell-scape born from the ashes of Los Angeles, San Diego, and Santa Barbara. The local cops, whose most daring task to date has been issuing citations for swearing, prove hilariously inept. Enter John Spartan, freshly defrosted to hunt his old nemesis, now partnered with Officer Lenina Huxley, a wide-eyed 20th-century enthusiast who seems to mistake Spartan for her dream Tinder date.

Here's where the Brave New World parallels slam into your face like a poorly aimed cattle prod. Huxley—yes, as in Aldous—and Lenina, named for Huxley's Brave New World heroine, are about as subtle as the film's Taco Bell product placement. Like Huxley's novel, Demolition Man paints a technocratic society built on order, cleanliness, and safety at the expense of freedom, individuality, and a soul. But this isn't the jackbooted dystopia of Orwell's 1984. No, this is dystopia-lite™, sanitised and shrink-wrapped for mass consumption. Compliance isn't enforced through terror; it's engineered through comfort. Why resist when you can bliss out on jingles and Taco Bell? (Or Pizza Hut, depending on your region, because branding is just another form of thought control.)

And oh, the cultural neutering. Music? Reduced to advertising jingles. Art? An afterthought. Even food is stripped of diversity. All restaurants are Taco Bell now—a perfect metaphor for a society where the illusion of choice masks the suffocating sameness. The film-makers even lampshade this brilliantly by lazily overdubbing Taco Bell with Pizza Hut for European audiences, a laughably Orwellian display of airbrushed reality that's too shoddy to take seriously.

But unlike Brave New World, there's no "Savage Reservation" here to contrast the sterile utopia. Instead, we get the Scraps: a ragtag group of sewer-dwelling rebels who live off society's cast-offs. They're not a true alternative; they're parasites, feeding on the technocracy they loathe. They're more Eloi-and-Morlock cosplay than functional counterculture. Even their rebellion—scrawling graffiti and looting Taco Bells—is pathetic in its impotence. They are the antithesis of revolution, too comfortable in their squalor to overthrow the system that oppresses them.

And looming over it all is Dr. Raymond Cocteau, the quintessential technocrat. He's every billionaire "philanthropist" rolled into one smug package: proclaiming benevolence while quietly orchestrating oppression. Cocteau doesn't need stormtroopers or torture chambers; he's mastered the art of ruling through psychological submission. Why use a whip when you can dangle a carrot? His downfall, of course, is his hubris: unleashing Simon Phoenix to do his dirty work, arrogantly assuming he can control the chaos he's unleashed. Spoiler alert—he can't.

Ultimately, Demolition Man isn't just an explosion-filled romp; it's a sneaky critique of our willingness to trade freedom for comfort, individuality for safety. Sure, you can live in the sanitised glow of San Angeles, putting credits in the swear jar and humming along to the Jolly Green Giant. Or you can eat rat burgers in the sewers, free but filthy. The

film forces us to confront an uncomfortable question: Is it better to live in gilded chains or dirty freedom? And in a world where dystopia creeps in through a series of tiny, comfortable concessions, that question feels more relevant than ever.

Dredd on Screen

The Law, the Legend, the Looming Nightmare

OBLIVIONMEDIA.SUBSTACK.COM

Dredd on Screen

The Law, the Legend, the Looming Nightmare

I've previously hinted at my love-hate relationship with 2000AD's infamously psychotic law-man, Judge Dredd. It's the kind of relationship one might have with a razor: efficient, dangerous, and occasionally satisfying, but with an ever-present risk of haemorrhaging. Dredd embodies a peculiarly British capacity for being both prophetically insightful and catastrophically blind, a caricature of the American justice system writ large with the subtlety of a sledgehammer wielded by a man in a Giant Eagle pauldron.

Dredd's first rampage through the pages of late-70s comics painted him as a steroidal Dirty Harry clone, stomping around a dystopian Mega-City soaked in crime and filth. It was less a portrait of justice and more a grimy love letter to authoritarianism, penned by a society that couldn't decide whether it feared or fetishized its imperial decline. As someone born after the fact, my impressions of the era are filtered through a toxic cocktail of half-remembered VHS rentals, hazy nostalgia goggles, and the sweet, cloying taste of weaponized "member-berries."

When Sylvester Stallone donned the helmet (well, briefly) for 1995's Judge Dredd, the character finally broke free of niche British cynicism to become a garish international spectacle. Say what you will about that film —it's a neon-drenched exemplar of 90s Cinema Aesthetic. The sets, gloriously fake. The colours, saturated to comic-book perfection. The action, gleefully absurd. Sure, the dialogue is cornball enough to choke a chicken, but at least it was fun. It didn't ask you to take it seriously. It winked at its audience with every explosion and groan-worthy one-liner.

Contrast that with the grim and gritty 2012 reboot, Dredd, which traded in cartoonish bombast for brutal realism, reimagining Mega-City One as a festering urban sprawl straight out of District 9. Gone were the bright hues and tongue-in-cheek theatrics; in their place, we got a dirtier, nastier world, one that felt less like dystopian fantasy and more like a documentary filmed in the darkest corners of Johannesburg.

These films don't just exist in different genres; they inhabit entirely different cultural spaces. The '95 version is a macro-level Hollywood fairytale—big villains, bigger conspiracies, and an uplifting finale where justice prevails and the hero rides off into the sunset. It's naïve, bombastic, and deeply optimistic in the way only '90s cinema could be.

Dredd (2012), by contrast, doesn't give a damn about saving the world. It's micro-level, almost claustrophobic—a single building, a single day, a handful of murders. No grand revelations, no systemic change, just a lot of bad people killing each other in creative ways while Dredd and his rookie partner try to survive.

And speaking of rookies: Anderson, the psychic cadet, is the heart of the 2012 film. Dredd himself is less a character and more a force of nature—an avatar of unyielding law, devoid of nuance or personal growth. Anderson, by contrast, is human. She starts off unsure, out of her depth, but by the end, she's found her strength without losing her compassion. In her, we see a glimpse of what justice could be: thoughtful, contextual, humane.

Dredd? He's none of those things. He's rigid, brutal, and entirely uninterested in extenuating circumstances. His moral compass points due north, even when north is a cliff. Admirable? Maybe. Terrifying? Definitely. He's the guy you want when a psycho with a chainsaw is kicking down your door, but the moment you jaywalk, he's slapping you with 20 years in the Iso-Cubes.

This duality—Dredd's incorruptibility versus his complete lack of humanity—is where the film finds its most biting commentary. The law, as Dredd sees it, is sacrosanct. But laws are only as good as the people who enforce them, and history has shown us that laws are often weapons wielded by the powerful to crush the powerless. Slavery, genocide, gulags—these weren't failures of the law; they were the law. And Dredd, in all his brutal glory, is a grim reminder of what happens when we mistake laws for justice.

The film subtly critiques the militarisation of police forces, the fetishization of "law and order" as an end unto itself. Dredd is a super-cop mythologised to terrifying perfection: incorruptible, unstoppable, and utterly blind to the grey areas of human existence. Anderson, meanwhile, represents the opposite—someone willing to bend the rules in the name of actual justice, someone who sees laws as tools rather than holy writ. Her decision to let the tech guy go, despite his crimes, isn't a failure of law enforcement; it's a triumph of morality.

And yet, Anderson's psychic powers introduce a new layer of unease. Sure, she's compassionate now, but give her five years of reading the minds of murderers and paedophiles, and who's to say she won't turn into another Dredd? Or worse, imagine a corrupt psychic judge—one who

97

weaponises people's private thoughts to entrench power. The Orwellian implications write themselves.

In the end, Dredd (2012) doesn't offer easy answers. It's a violent, stylish action movie that also forces you to confront uncomfortable truths about power, justice, and the systems we rely on to maintain order. The fight against evil, as the film suggests, is endless. There are no sunset endings here, just another day in the endless grind of humanity's worst impulses.

Is Dredd a hero or a monster? That's the question at the heart of his mythology, and the answer, infuriatingly, is both. He's the best and worst of law enforcement distilled into a single character, a figure who forces us to grapple with the uncomfortable reality that justice, in the end, is less about rules and more about the people who wield them.

And maybe that's the real brilliance of Dredd. It doesn't pretend to have solutions. It just holds up a mirror—and the reflection isn't pretty.

Why I Walk

It's not rocket science

Why I Walk

It's not rocket science

As I've stated in the description of my Substack—though I doubt most of you bothered to read it—the inspiration for my articles arises from what, to the average "normie," would be considered mental downtime during my daily exercise routine. The most time-consuming of these is my five-mile walk, which, yes, is the origin of my Substack's oh-so-clever name.

Some of the comments and messages I've received regarding how I juggle my "enforced" versus "chosen" lifestyle have been so ludicrously misguided that I feel compelled to address them, if only to stem the tide of further nonsense.

For those blissfully unaware of my situation (how nice for you), here's the rundown: I'm a divorced father of two, slogging away at a dead-end, minimum-wage job, running a modest 3D printing and small livestock side hustle, and writing this Substack in the scraps of free time I manage to carve out of my so-called life. Despite this whirlwind of obligations, I religiously set aside time for at least five miles of walking—or an equivalent exercise session—every single day.

Why? Because, unlike much of the population, I actually value time to think. This exercise period allows my mind to roam freely, unfettered by the suffocating constraints of daily drudgery. The result? These articles—eclectic, opinionated, and entirely reflective of the unfiltered inner monologue that plays out while I'm trudging through another five miles.

Now, let's address the utterly baffling remarks some people make about my supposedly "arbitrary" goal of five miles. Two simple points should suffice:

From my doorstep to my usual turnaround point and back—thank you, Ordnance Survey app—the route conveniently totals 4.97 miles. Round it up if it makes you feel better.

A few years ago, in yet another doomed attempt to tackle Britain's national inertia, some genius public health campaign slapped a 10,000 steps a day target on the populace. For those incapable of basic conversions, that's roughly five miles. But wait, there's more! In early 2024, this target was halved to 5,000 steps because apparently five miles was too much for most people to handle. Five miles. Too much. I despair.

Unlike a certain someone I could mention—Hi Corrine, you vacuous, attention-seeking meat potato—I am acutely aware that I'll never again be the absolute unit I was 20 years ago. And you know what? That's fine.

I've embraced the Dad-bod era with open arms and a well-adjusted sense of realism. Unlike some, I don't cling desperately to delusions of eternal youth or pine for days long gone. Instead, I prioritize staying healthy—not because I'm chasing some mythical fountain of youth, but because I'd like to avoid the slow-motion train wreck of poor health that inevitably follows neglect.

Let's be clear: maintaining a basic level of fitness isn't about vanity. It's about not having to worry that one day I'll keel over from simply tying my shoes. A little effort now—some light jogging, a few push-ups, even just regular walks—pays massive dividends when life inevitably throws a curveball. If you need proof, look no further than my ex-wife. Bless her, she's practically a walking PSA for why neglecting your health is a terrible idea. At well over 25 stone, even the simplest tasks have become monumental challenges. Movement for her is less locomotion, more a tragic symphony of wheezing and collapsing. Fifteen feet? A Herculean ordeal. Fifteen miles? She'd need divine intervention. Meanwhile, I can hike that distance in a day and still have the energy to cook dinner afterward.

But I digress. This isn't just a bitter rant or a roast session (though, let's be honest, some people make it so easy). There's actual science to this, and I'd like to share it with you.

Let's not mince words—walking five miles daily is one of the simplest, most effective ways to dramatically improve your health. This isn't a sales pitch; it's a fact, backed by mountains of research and centuries of common sense. Yet, somehow, in the age of convenience and couch-induced apathy, even this no-brainer eludes the masses. So, here's your wake-up call: this low-impact, utterly accessible activity can transform your physical health, mental sharpness, and emotional stability. Let's unpack the benefits, for those still dragging their feet.

Medical Benefits

Walking is the cornerstone of cardiovascular health. By boosting circulation, lowering blood pressure, and slashing cholesterol, it fosters a heart and vascular system that actually works—imagine that. Research shows a 30% reduction in the risk of cardiovascular disease for people who make walking a habit. Pair it with a diet that doesn't include a daily sugar coma, and you're golden. Honestly, how this isn't common practice is baffling. It's like the world collectively decided, "Eh, let's skip the one thing that's free and proven to keep us alive."

Burning 300–500 calories on a five-mile walk? Yes, please. Your exact numbers will vary based on weight, speed, and terrain, but the takeaway is clear: walking helps manage weight without turning your life into an unending slog of meal-prep misery. It boosts your metabolism, encourages fat burning, and avoids the drudgery of gym machines. If obesity were treated as the ticking time bomb it is, we'd have people marching in the streets—and they'd literally lose weight doing it.

Oh, and if you're battling type 2 diabetes, walking is your best friend. Regular strolls improve insulin sensitivity and blood sugar regulation. No, it's not magic, and yes, it's better than trying to hack your glucose with overpriced gadgets. Just lace up your shoes and go—because apparently, that's too much effort for some.

Walking strengthens your bones and joints, reducing the risk of osteoporosis and arthritis. It also helps lubricate your joints, easing stiffness. Take it from someone who spends most of their day stiff as a board in a soul-sucking job: a quick walk is a game-changer. Who knew moving your body could actually make it feel better? Revolutionary stuff, really.

And let's not forget immunity. Regular walks activate natural killer cells (yes, that's a real thing) and boost antibody responses. So while everyone else is downing overpriced supplements and praying to avoid the latest viral plague, you'll be out there, casually strolling your way to a stronger immune system.

Psychological Benefits

Walking is nature's Prozac, plain and simple. It floods your system with endorphins, lowers cortisol (that stress hormone that's basically killing you), and fosters emotional balance. Toss in some greenery or a park trail, and the benefits multiply. And yet, so many people would rather stew in their stress than spend 30 minutes outside. Amazing.

Feeling down? A brisk walk can help. Studies show walking significantly reduces depression risk, boosting levels of serotonin and dopamine—your brain's happiness chemicals. A 2021 JAMA Psychiatry study even pinpointed the sweet spot: 4,400–6,000 steps daily. That's right, you can actually fend off depression by walking out your door. Or, you know, keep staring at your phone and wondering why life feels like an endless pit of despair. Your call.

Cognitive benefits? Walking stimulates blood flow to your brain, promoting neurogenesis and keeping your mind sharp. Regular walkers

enjoy improved focus, better memory, and a lower risk of dementia. So, while others let their brains rot with mindless screen time, you could be strolling your way to intellectual longevity.

And let's not overlook the impact on sleep. Walking regulates your circadian rhythm, helping you fall asleep faster and sleep deeper. Go for an evening walk, take a shower, and you'll be out like a light. But sure, keep scrolling TikTok at midnight if that's working for you.

Lastly, there's the sense of accomplishment. Meeting a daily walking goal boosts self-esteem and motivates you to tackle other areas of life. It's a cascading effect of productivity and positivity. But hey, if achieving nothing and feeling terrible is more your speed, far be it from me to interfere.

The Bottom Line
Walking five miles a day isn't just an activity—it's a keystone habit that lays the foundation for a healthier, more balanced life. It's transformative, accessible, and requires nothing but your own two feet. By walking regularly, you're not just investing in the now—you're safeguarding your future.

So, carve out the time. Ditch the garbage TV show, pause the video game, and stop pretending you're too busy. None of that is real; none of that is helping you. What will help you is putting on a pair of shoes and taking a walk. It's simple, it's effective, and frankly, it's long overdue.

The Real Lessons of Nineteen Eighty-Four

The points that everyone misses.

The Real Lessons of Nineteen Eighty-Four

The points that everyone misses.

George Orwell's Nineteen Eighty-Four is not just a cornerstone of modern literature; it's the omnipresent spectre haunting every political conversation in the English-speaking world. No book has been so relentlessly cited, misquoted, and misappropriated by ideologues of every stripe. Orwell's dystopia, a dissection of early 20th-century totalitarian regimes, has metastasised into a catch-all warning label for any policy someone dislikes. Terms like Orwellian, Big Brother, Doublethink, and Thought Police are casually flung about, often by people who wouldn't recognise the Party's principles if they were tattooed on their foreheads. Worse still, many critics accuse their enemies of treating Orwell's work as an instruction manual—an accusation that lands uncomfortably close to the truth more often than it should.

At its heart, Nineteen Eighty-Four is not about jackboots and gulags, though those make their chilling appearances. The true tyranny, Orwell argues, lies in the annihilation of independent thought. The real battleground is not the street but the mind. Winston Smith's daily chore of rewriting inconvenient truths at the Ministry of Truth is a grim reminder that history, like reality itself, is alarmingly pliable in the wrong hands. The systematic pruning of the Newspeak dictionary, meanwhile, underscores the horrifying idea that language—our most fundamental tool for communication—is easily weaponised against us. Orwell's genius lies in exposing how totalitarian control doesn't merely silence dissent; it erases the very possibility of dissent by rendering critical thought linguistically impossible.

Nineteen Eighty-Four isn't just a dystopian manual for a bygone era; it's an exploded view of the modern world's engine, laid bare for all to see— though our real-world equivalents often operate with more subtlety and finesse. Take the telescreen, for instance: Orwell's blunt-force depiction of propaganda delivery and surveillance, a device that can't be turned off and watches everyone within range. Crude? Sure. But the 21st-century update is far more insidious—a seamless blend of corporate and government collaboration, delivering an endless stream of establishment-approved narratives while hoovering up obscene amounts of data on what we consume, where we go, and who we associate with. Orwell imagined a government imposing control through a glowing screen; we've willingly invited dozens into our homes, pockets, and wrists.

And yet, the telescreen is just the tip of Orwell's iceberg. The true genius of Nineteen Eighty-Four is its dissection of a system where the bounds of thought itself are policed. For most of history, crime was defined by action —what one did. Later, it expanded to possession: illegal drugs, unregistered weapons, banned books. Under repressive regimes, even owning subversive material became a crime. Orwell, however, takes us to the dystopian zenith: thought-crime—the mere act of harbouring a prohibited idea. In the world of INGSOC, obedience is insufficient; it's not enough to comply with Big Brother—you must love him. This isn't achieved with threats alone but by reshaping minds, forcing citizens into the mental straitjacket of doublethink: the ability to hold and believe mutually contradictory ideas without a hint of cognitive dissonance.

It's important to clarify what doublethink truly is, as the term has been cheapened in popular discourse. It's not mere hypocrisy, like a gun-banning politician with armed bodyguards—that's elitist cynicism, not doublethink. True doublethink requires an almost religious devotion to two ideas that cannot logically coexist. This mental discipline isn't some far-flung dystopian relic; it's alive and well, coursing through the veins of modern political discourse. Consider this: to simultaneously declare "America First" while demanding unconditional support for Israel—despite the frequent misalignment of those priorities—requires a neat bit of doublethink. Similarly, proclaiming "trans women are women" while maintaining that "trans is a distinct identity with its own rights" rests on a tension of being both identical and distinct. On the macro level of conceptual manipulation, these contradictions are not accidents; they are deliberate frameworks designed to corral thought along predetermined paths.

When confronted with these contradictions, the typical response exemplifies the very mechanisms Orwell described. Any critique of trans activism? Transphobia. A word about Israel's policies? Antisemitism. These terms are wielded not as tools for meaningful dialogue but as blunt instruments of intellectual enforcement. Their purpose is not clarity but to shut down conversation entirely, ensuring that critical thought is smothered under the weight of predetermined moral judgments. Even the terms themselves—"transphobe" and "antisemite"—are worth unpacking. Both function as linguistic cudgels, curiously resistant to nuance and tailored to corral dissent into a narrow, reactionary space.

This is no accident. Modern political language is an iceberg of deliberate manipulation. Beneath the surface lies a sprawling machinery of carefully

crafted terms and frameworks, all designed to constrain thought and preordain conclusions. Context is squeezed out, variability dismissed, and individuals are left with only two pre-packaged positions to choose from: for or against, with us or against us. This doesn't just eliminate the need for thought—it automates it. Debate devolves into the regurgitation of prefab slogans, packaged as moral imperatives.

Propaganda plays its part, of course, typically by sanctifying one's cause while demonising the opposition. "God is on our side" is the oldest trick in the book, now repackaged into neat binaries like "pro-life" versus "pro-choice." Notice how neither side dares identify as anti-something; that would sound too negative, too aggressive. Instead, the language is engineered to sound unassailable, its edges sanded down to a moral sheen. Who could oppose life? Who could be against choice? Then there's the insidious creep of terms like "hate speech," designed to sound indefensible and wielded to cordon off increasingly broad swaths of debate. Initially framed around overt bigotry, the concept soon expands to include anything inconvenient to the powers that be—say, critiques of immigration policy.

Marxism and Fascism are infamous for crafting ideas that mean precisely the opposite of what they claim. Freedom through dictatorship, equality through class warfare, peace through conquest—it's a rhetorical sleight of hand as old as ideology itself. Modern political movements are no different; they churn out their own lexicons to frame narratives, each as manipulative as the last. Whether it's the pseudo-science of Nazi racial hierarchies, Marxist class struggle, or the jargon-laden dogma of modern identity politics, the goal is the same: "to dehumanize individuals into nothing more than interchangeable cogs in a grand ideological model."

Under this framework, people cease to be complex, unique beings and instead become assigned roles in an unrelenting moral pageant. The bourgeoisie is forever locked in combat with the proletariat. The white cis-male is painted as the innate adversary of BIPOC. The labels change, but the reductive absurdity remains constant—a tedious script recycled with fresh buzzwords to match the fashion of the age. It's not about understanding people; it's about forcing them into prefabricated roles in a simplistic binary of oppressor and oppressed. Like a badly written soap opera, the story-lines are predictable, the characters caricatures, and the outcomes foregone.

What's astonishing isn't just the intellectual laziness of these frameworks but their astonishing durability. Despite their obvious flaws, they endure—

unquestioned by those who find comfort in their simplistic moral clarity. After all, why grapple with the messy complexities of humanity when you can distil it down to tidy narratives that tell you who to blame, who to hate, and who to revere? It's not just nonsense; it's weaponized nonsense, designed to strip away critical thought and leave in its place the smug satisfaction of ideological certainty.

Newspeak takes linguistic control to its logical extreme because the Party isn't content with merely shaping ideological jargon—it demands dominion over language itself. It's not enough to regulate the words of the politically engaged or to enforce orthodoxy among Party faithful. No, Newspeak is the totalitarian dream of universal censorship, a system where rebellion isn't just suppressed but rendered unthinkable. Want to fire off a seditious tweet? Good luck when the words to articulate dissent no longer exist. "Big Brother is doubleplus ungood" isn't exactly the rallying cry to stir an uprising. By narrowing the scope of language, Newspeak doesn't just limit what people can say; it amputates what they're even able to think. It's an automation of thought itself, stripping away the messy creativity and complexity of human ideas and replacing them with pre-approved templates.

This Orwellian nightmare isn't entirely hypothetical. There's precedent for the marriage of linguistic sterilization and ideological conformity, and it's as absurd as it is chilling. Enter Aleksei Gastev, a Soviet-era oddity—a labour theorist, poet, and proto-dystopian tinkerer—who led the Central Institute of Labour in the 1920s. Inspired by Frederick Taylor's "scientific management," Gastev wasn't satisfied with merely optimizing Soviet factories; he dreamed of mechanizing the human mind in the name of efficiency. Just as he sought to streamline motion and workspace layouts, Gastev aimed to pare down the Russian language itself. Flowery prose? Gone. Redundant words? Erased. Why waste time on nuance when you can churn out streamlined, Marxist-approved messaging at maximum efficiency? His project, fortunately, never left the drawing board, but Orwell's Newspeak shows us where such schemes inevitably lead—not just to a smaller dictionary but to a linguistic straitjacket, one that allows only thoughts that serve the regime.

Newspeak doesn't just simplify language; it lays out a map for permissible thought, littered with dead ends for anything remotely resembling a subversive idea. It doesn't merely punish thought crime; it prevents it from forming in the first place. Combined with the mental gymnastics of doublethink—the ability to believe mutually exclusive ideas

without batting an eye—you have a recipe for absolute control. Orwell dramatizes this beautifully in Nineteen Eighty-Four with Hate Week, a grotesque festival of national rage directed at Oceania's enemy, Eurasia. The event builds to a crescendo with speeches, propaganda, and public executions, only to suffer a "minor inconvenience" midway through: the enemy abruptly changes.

In one of the novel's most cutting scenes, a Party orator receives a note mid-speech informing him that Oceania is, in fact, at war with Eastasia, not Eurasia. Without missing a beat, the names change. The audience—whipped into a feral frenzy—doesn't hesitate. They rip down the "wrong" banners, shred posters, and seamlessly redirect their hatred toward the new enemy. The spectacle resumes as though nothing happened. Orwell's depiction is absurd, yes, but only by degrees. Modern media achieves the same effect at a slower tempo. A perfect example? August 2024, when the media unanimously parroted that Joe Biden was "sharp as a tack" and any doubts about his cognitive state were baseless conspiracy theories. Then, seemingly overnight, the script flipped. The same media outlets declared his mental decline undeniable—because his own party had decided it was time for him to go.

It's the same mechanism, albeit with days instead of minutes between reversals. Social coercion, immersion in narrative, and the endless feedback loop of ideological reinforcement create a reality where the "correct" belief is whatever you're told it is today. Resistance isn't punished with Room 101 (yet); more often, it just earns you social ostracism, trolling, or a professional black mark. But the pressure is real, and it's unrelenting.

Take, for example, the rollout of Big Pharma's "Special Sauce" in 2020. No one was dragged to the clinic at gunpoint, but the combination of narrative engineering, workplace incentives (and threats), and relentless social shaming made compliance the only "reasonable" choice for most people. Refusal wasn't framed as scepticism; it was cast as a moral failing. People weren't forced—they were conditioned. Refusing the jab wasn't just seen as a personal decision but as a betrayal of society, a failure to conform to the socially approved answer.

This kind of coercion isn't just about individual issues; it's a systemic feature of ideological conditioning. Political opponents aren't merely wrong—they're immoral, subhuman even. And when ideological alignment becomes synonymous with virtue, objectivity dies. The cost of critical thinking becomes too high because questioning the narrative isn't

just inconvenient; it's a betrayal of one's very identity. After all, how can you consider alternative views when doing so means abandoning the moral high ground you've been trained to cling to?

Look no further than China's social credit system for a contemporary example of Orwellian principles in action. Sure, it's more overt and clumsy —public shaming, travel bans, financial penalties—but it operates on the same basic principle: obedience or inconvenience. The power structure defines "what you should do," and if you step out of line, life becomes a labyrinth of locked doors and impossible hurdles. It's somewhere between a digital nagging nanny and the full-blown nightmare of Oceania under INGSOC. But let's not kid ourselves: Oceania is no ordinary dystopia; it's a permanent, centrally planned war economy where hatred is both policy and entertainment.

The Party's dual enemies are both calculated and essential. There's the external foe—whichever superstate Oceania is at war with today—and then there's Emmanuel Goldstein, the eternal scapegoat and bogeyman of the regime. Goldstein, a Trotsky-like figure, is framed as the ideological Judas of INGSOC: pivotal to its rise yet conveniently recast as the arch-traitor. He is less a man than a construct, a vessel into which all evils are poured, his name a perpetual excuse for every failure and an outlet for every frustration. Even the so-called resistance against the Party is a trap, a staged pantomime to root out dissenters. When Winston Smith—our sad, unheroic narrator—is roped into this faux-rebellion, he's given a book, The Theory and Practice of Oligarchical Collectivism. Authored by Goldstein (or so they claim), the text lays bare the mechanics of Oceania's perpetual war and the purpose it serves.

The war among Oceania, Eurasia, and Eastasia isn't a desperate existential struggle; it's a carefully managed stalemate, a conflict of convenience rather than conquest. None of the superstates dares risk genuine defeat, nor do they have any ideological differences that would justify annihilating one another. Instead, the war exists to perpetuate the system. As Goldstein explains, war is no longer a fight for survival or resources—it's a tool to sustain societal control:

"In one combination or another, these three super-states are permanently at war, and have been so for the past twenty-five years. War, however, is no longer the desperate, annihilating struggle that it was in the early decades of the twentieth century. It is a warfare of limited aims between combatants who are unable to destroy one another, have

no material cause for fighting, and are not divided by any genuine ideological difference."

This is war as economic management, war as social stability. War is peace. The conflict is fought on distant peripheries, consuming resources without ever threatening the superstates themselves. Factories churn out weapons, mines produce endless raw materials, but the fruits of this labor never reach the people. The goal isn't victory—it's consumption. Goldstein notes the paradox: the purpose of modern war isn't to defeat an enemy but to destroy surplus production without improving anyone's quality of life.

"The primary aim of modern warfare... is to use up the products of the machine without raising the general standard of living."

Why? Because a prosperous, well-fed, and leisurely working class might start asking uncomfortable questions—questions like, "Why do we need this hierarchy at all?" Better to keep the masses exhausted, distracted, and struggling to make ends meet.

Fast forward to today, and while our system isn't quite Oceania, some of its principles feel eerily familiar. Consider the military-industrial complex, which thrives on endless, unwinnable conflicts fought on foreign soil. The wars aren't designed to be decisive but to keep the gears of production turning and the balance of power intact. Replace Oceania's Forever War with the modern War on Terror, or the ongoing proxy war in Ukraine, and the similarities write themselves.

It's a war that both sides are invested in sustaining but not in winning outright. Russia, for all its bluster, hasn't obliterated Ukraine as it theoretically could, holding back from outright annihilation. Meanwhile, NATO keeps the conflict simmering by funnelling just enough ammunition, equipment, and support to keep Ukraine in the fight without offering the tools for a decisive victory. The result? A bloody stalemate that consumes vast resources, bolsters the defence industries of both blocs, and ensures geopolitical tension remains high.

For Russia, the war props up its defence industry and rallies nationalist sentiment. For NATO, it's an opportunity to offload old munitions, justify new military budgets, and ensure a steady demand for weapons manufacturing. Everyone profits—except, of course, the people dying in the trenches.

And speaking of trenches, isn't it fascinating how modern technology has paradoxically dragged us backward? The conflict in Ukraine has brought trench warfare—something we thought belonged to history—back into relevance. Drones, cheap and ubiquitous, provide battlefield-wide surveillance and disrupt the manoeuvre warfare tactics that have dominated military doctrine since World War II. Tanks, once the king of the battlefield, now struggle to survive against remote-controlled drone strikes and man-portable anti-armour systems. Air superiority, long the cornerstone of modern warfare, is increasingly tenuous thanks to portable anti-aircraft weapons.

Sure, this isn't a permanent regression. The history of warfare is one of adaptation, and new designs and tactics will emerge to counter these trends. But for now, the battlefield looks unsettlingly like something out of the early 20th century—proof that technological advancement doesn't always move us forward.

The parallels to Orwell's Nineteen Eighty-Four are striking. While our wars aren't as neatly organized into three blocs, the essence remains: conflicts that can't be decisively won, sustained for the benefit of elites, and fought far from the comfortable metropolis that fund them. Goldstein's analysis of Oceania's system might as well be a commentary on our own:

"Goods must be produced, but they must not be distributed. And in practice, the only way of achieving this was by continuous warfare."

The machinery of war isn't just about profit; it's about preserving the existing power structure. Victory is unnecessary, defeat unthinkable, and the masses? They're just cogs in the machine, pacified by propaganda while the war grinds on. Orwell didn't write a prophecy—he wrote a mirror. And if we don't like the reflection, maybe it's time to ask why we keep polishing the glass.

Emmanuel Goldstein is a fascinatingly slippery figure in *Nineteen Eighty-Four*, less a character and more a prism through which Orwell dissects authoritarianism and ideology. He first appears during the Party's grotesque ritual, the Two Minutes Hate, where he's portrayed as INGSOC's ultimate arch-traitor—the regime's Satan incarnate. He is *the* bogeyman, the scapegoat for all of society's ills, a cartoon villain that people can project their fears and frustrations onto. Later, he resurfaces as the alleged founder of the Brotherhood, a shadowy resistance movement dedicated to overthrowing the Party. Finally, through *The*

Theory and Practice of Oligarchical Collectivism, the manifesto attributed to Goldstein, he becomes a mouthpiece for Orwell's own exploration of totalitarian structures and the bleak dynamics of power.

But let's be clear: Goldstein is no hero. He's not even likeable. His book might expose the Party's lies and mechanisms of control, but it's not written in the voice of a passionate revolutionary. It's cold, analytical, almost dispassionate—more the detached musings of a theorist than the fiery call to arms of a freedom fighter. And here's the kicker: we can't even be sure Goldstein wrote it.

O'Brien, Winston's tormentor and Inner Party puppet master, suggests that the book might be a lure—a fabrication penned by Party loyalists to entrap dissenters. Or maybe Goldstein did write it, and the Party repurposed his work to suit their narrative. Or perhaps it's a product of committee, an amalgam of convenient ideas designed to give the illusion of a cohesive resistance. It doesn't matter. The real point is what Orwell is telling us through this ambiguity: **truth is irrelevant in a system that controls reality itself**.

This brings us to Orwell himself, claimed by every stripe of dissident like some intellectual piñata, each faction banging away to extract the juicy bits that support their agenda. He's often misrepresented, reduced to a simple anti-socialist or anti-communist voice. In reality, Orwell was a socialist—just not Stalin's kind. He was vehemently anti-authoritarian, a man who despised the Soviet knock-offs of socialism as much as he loathed fascism. INGSOC (short for English Socialism) is a satire, a grotesque distortion of socialism used to illustrate the dangers of authoritarian centralization.

Goldstein himself can be seen as Orwell's sardonic take on Marx. Like Marx, Goldstein presents a class-based analysis of history:

> *"Throughout recorded time, and probably since the end of the Neolithic Age, there have been three kinds of people in the world, the High, the Middle, and the Low... Even after enormous upheavals and seemingly irrevocable changes, the same pattern has always reasserted itself, just as a gyroscope will always return to equilibrium, however far it is pushed one way or the other."*

Goldstein argues that this perpetual class struggle is an immutable law of human society, framing his ideas in deterministic, pseudo-scientific

terms. Then, in a move straight out of Marx's playbook, he offers a mechanism to break the cycle: a theoretical "end of history" where class hierarchies are stabilized forever.

But Orwell isn't handing Goldstein—or Marx—a free pass. In fact, he's gutting them with satire. The so-called end of history that Goldstein predicts isn't liberation; it's an endless nightmare of authoritarian control masquerading as stability. The title of Goldstein's book, *The Theory and Practice of Oligarchical Collectivism*, gives the game away: it's about the concentration of wealth and power in the hands of a tiny elite under the guise of collectivism. Sure, the state owns everything, but who actually benefits? The Inner Party. They live in the best homes, eat the best food, and enjoy all the comforts denied to the proles. But technically, they don't "own" anything—so it's still "collectivism," right? It's linguistic acrobatics designed to gaslight the masses, a perfect encapsulation of Orwell's concept of Newspeak.

If Goldstein is Orwell's satirical Alt-Marx, then O'Brien is his devil's advocate, stripping away the façade of ideology to lay bare the raw machinery of power:

> *"The German Nazis and the Russian Communists came very close to us in their methods, but they never had the courage to recognize their own motives... Power is not a means; it is an end. One does not establish a dictatorship in order to safeguard a revolution; one makes the revolution in order to establish the dictatorship. The object of persecution is persecution. The object of torture is torture. The object of power is power."*

This chilling confession is the cornerstone of Orwell's critique. O'Brien openly admits that INGSOC, like its real-world analogues, isn't about creating a utopia or serving the people—it's about consolidating power for its own sake. And here's the uncomfortable twist: Goldstein and O'Brien agree on the Party's methods. They both understand how the Party maintains control—through perpetual war, thought manipulation, and the rewriting of history. The only difference is their ideological spin. Goldstein believes these mechanisms can be dismantled; O'Brien insists they are eternal.

Goldstein's book is thus a multi-layered critique—not just of Stalinism but of any system that concentrates power under the guise of collectivism. As

O'Brien sneeringly puts it, the book's descriptions are accurate, but its solutions are laughable. It's a savage deconstruction of Marxism, state socialism, and all the other ideologies that promise equality while delivering oligarchy.

Orwell's genius lies in the way he exposes the paradox of oligarchical collectivism: the state claims to represent the people while hoarding all wealth and power for itself. The oligarchs live like kings but pretend to be humble servants of the collective good. It's collectivism in name only—a grotesque charade that twists language and ideology into tools of oppression.

Ultimately, Goldstein is not a hero, a villain, or even a person. He's a mirror held up to ideology itself, reflecting the ways in which power structures manipulate belief to sustain themselves. Orwell doesn't give us a clear answer as to whether Goldstein is real or fabricated, because the truth doesn't matter in a system where lies have more utility. And that, in the end, is Orwell's bleakest point: when power becomes its own justification, everything else—truth, morality, freedom—is just collateral damage.

And so we return to Winston Smith, toiling away at his desk in the Ministry of Truth—a lowly cog in the Party's relentless machine of deception. His job? To rewrite history on command, aligning the past with the ever-shifting dictates of the Party. Call him a "fact-checker," if you're feeling generous, though his task has less to do with verifying facts and more to do with annihilating them. If the Party declares a fact inconvenient, Winston dutifully airbrushes it out of existence. An unpersoned Inner Party member? No problem—Winston replaces them in the records with some fabricated war hero. The discarded truth is ceremonially destroyed, swallowed by the "memory hole," a fittingly melodramatic touch in the theatre of totalitarian control.

This isn't just about changing the record; it's about obliterating memory. The Party's genius lies in its understanding of human psychology. It doesn't merely rewrite the past; it conditions people to forget it ever existed. *Doublethink*—the ability to hold two contradictory beliefs and accept both as true—cements the illusion. Winston is both a tool and a victim of this system. He can perform the necessary mental gymnastics to rewrite yesterday's truths, but not without struggle. He remembers things—dangerous things. Once, he even kept a photograph, a physical token of the past. For a man like Winston, in a world like *Nineteen Eighty-Four*, this is not rebellion; it's suicide.

Inevitable, then, that Winston stumbles into the trap. His scattered defiance makes him the perfect mark for O'Brien's FBI-style sting operation, baited with the promise of a revolutionary brotherhood. Winston, naïve and desperate, pledges to commit heinous acts against the Party—assassination, sabotage, you name it. But when the iron voice of authority finally orders him to stop, he obeys without hesitation. Facing imminent capture, with death a certainty, the idea of disobedience doesn't even occur to him:

> *"To run for life, to get out of the house before it was too late —no such thought occurred to them. Unthinkable to disobey the iron voice from the wall."*

This is cultural conditioning at its bleakest. Even as Winston knows he's doomed, fear of disobedience overrides any instinct for self-preservation. His submission is total, automatic—proof that the Party doesn't just control the body, but owns the mind.

In the holding cell, Winston encounters colleagues who've also been crushed under the Party's heel. Here, Orwell shows us the final piece of the puzzle: **the system thrives on manufactured threats.** The heretic, the traitor, the enemy of society—these figures must always exist, lurking in the shadows, ready to be exposed and humiliated for the masses. Whether these threats are real or fabricated doesn't matter. As Orwell writes:

> *"The heretic, the enemy of society, will always be there so that he can be defeated and humiliated over again."*

Sound familiar? Modern politics is no stranger to this play-book. Take the War on Terror—a bipartisan boogeyman that's kept us groped at airports, tracked through our devices, and watched by ubiquitous cameras for over 20 years. Yet, for all the invasive surveillance, real terrorist plots seem inconveniently scarce. No problem—the FBI just manufactures a few. Entrapment schemes, concocted plots, and orchestrated "foiled attacks" are fed to the public as proof of the system's necessity. It's all as fake as anything Winston Smith scribbled into his fabricated news columns.

And that's the point of *Nineteen Eighty-Four*: it's about the process of making people believe lies. It begins with passive manipulation—

manufacturing fear of phantom enemies, eroding reason through relentless propaganda. But Orwell takes us further. The last third of the novel is a surgical dissection of how totalitarian regimes break down individuality. Winston's defiance is stripped away through physical pain and the psychological humiliation of struggle sessions. When he's broken, the Party rebuilds him with its own definitions, its own reality. The words Winston once knew—freedom, truth, even numbers—are redefined. "2 + 2" can be four, five, or three, depending on the Party's whim.

This is the true horror of totalitarianism: it doesn't just demand obedience; it rewires the very way people think. Parrot the lies long enough, and some part of you starts to believe them. It doesn't even take electric shock torture in a dungeon. Orwell's dystopia is distinctly mid-20th century, with its flavour of grimy authoritarianism and looming bureaucratic terror. But the mechanisms he describes—*Newspeak*, *doublethink*, *crimestop*—remain relevant.

And no, it's not because *Nineteen Eighty-Four* is some prophetic manual for our future or a blueprint for the world we live in now. It's not an instruction manual for Big Brother, and it's not a perfect map of our modern political landscape. At best, it's an outdated guidebook, filled with unrecognizable streets but a few landmarks that still stand. What Orwell offers is a fable—a warning about how intelligent people can be made to believe absurdities when language and thought are manipulated.

Here's the uncomfortable truth: you don't need overt totalitarianism to see Orwell's warnings at play. We all engage in a little *doublethink*. We all resort to some *Newspeak*. And we all have our ideological Goldsteins— those figures we reflexively reject because we're conditioned to do so. Orwell's warning isn't just about governments; it's about us.

I'll leave you with this, from the book's appendix:

> *"Crimestop means the faculty of stopping short, as though by instinct, at the threshold of any dangerous thought. It includes the power of not grasping analogies, of failing to perceive logical errors, of misunderstanding the simplest arguments if they are inimical to INGSOC."*

It's a grim reminder that the greatest weapon of tyranny isn't the fist—it's the mind, quietly trained to obey without question. And that, more than anything, is what makes Orwell's vision so timeless.

A Rational Take on Trekonomics

To boldy theorise where no man has theorised before

A Rational Take on Trekonomics

To boldy theorise where no man has theorised before

Let's get something straight from the outset: this isn't going to be your typical tiresome rehash of Star Trek economics. You've heard it all before —endless, circular debates about how the Federation works, whether it's some futuristic form of communism, and how the oft-mentioned yet maddeningly vague "Federation credit" squares with the so-called moneyless society. Entire bookshelves of discourse have been erected around these questions, spawning think pieces, hot takes, and the occasional academic doorstop. For my research, I primarily leaned on Rick Webb's The Economics of Star Trek and Manu Saadia's Trekonomics. Both books bring something to the table, but let's be real: Webb's analysis outshines Saadia's by miles. Webb tackles how the Federation might actually function based on what's shown on screen, without wallowing in the quicksand of neo-liberal, Keynesian assumptions. Meanwhile, Saadia cites Paul Krugman in the acknowledgments. Yes, that Paul Krugman.

Of course, Star Trek is fiction. No one's suggesting it's an empirical model for organizing society. But it does offer some intriguing ideas, and the no-money economy is a particular lightning rod for debate.

Let me be clear about my thesis: the Federation operates as a post-scarcity economy. It's not capitalist—how can you have capitalism when your walls can spit out filet mignon and martinis on demand? But it's not communist either. Private property exists, glaringly evidenced by things like Château Picard. There's no indication of a centrally planned economy beyond the Starfleet shipyards. The Federation isn't just modern economics with shiny spaceships tacked on—it's something qualitatively different.

That said, post-scarcity doesn't mean infinite resources. Replicators can churn out food and cocktails, but Starfleet can't just replicate a fleet of Galaxy-class starships. Those still require massive construction efforts, which suggests there's an energy threshold where replicators stop being viable. It's an energy-based economy: replicators consume energy to convert digital patterns into material goods, and at some point, the energy cost to replicate something surpasses the cost of traditional manufacturing. But this limit doesn't matter much to your average Federation citizen. For them, life is basically a billionaire's fever dream:

no need to work, no existential dread over bills, and infinite leisure time. So why does anyone work at all?

There's an episode of Deep Space Nine that touches on this, where Jake Sisko smugly explains, "We work to better ourselves and the rest of humanity." Nog, the ever-practical Ferengi, shoots back with, "What does that even mean?" And that's the real question, isn't it? What does it mean to "work" in a society where no one has to? And how does society function if too many people simply don't?

These questions aren't just idle speculation. In 1964, a group of economists, scientists, and thinkers signed a document called The Triple Revolution. It argued that the relationship between jobs and income was breaking down due to three simultaneous upheavals. First, "cybernation"—essentially the automation of production—was driving productivity up while reducing the need for labour. Second, the advent of nuclear weapons created a military stalemate, ending the era when war could be an economic safety valve. And third, the civil rights movement was expanding the workforce by dismantling barriers for women and minorities, increasing the demand for higher living standards just as jobs were disappearing. In short, the workforce was growing while the demand for labour was shrinking—and you couldn't even solve it by building a massive standing army, unless you wanted to wage eternal, unwinnable wars.

This wasn't just theoretical hand-wringing. By 1969, none other than Richard Nixon floated a plan for cash assistance to every American family below the poverty line—what we'd now call a rudimentary Universal Basic Income. Adjusted for inflation, it was around $14,000 a year, a number that probably makes contemporary Americans laugh bitterly into their overpriced lattes. Naturally, the proposal was torpedoed by a bipartisan chorus of "This will create lazy moochers!" The plan was mangled into today's workfare programs, and George McGovern's push for a more robust basic income in 1972 didn't fare much better.

Now, with the first quarter of the 21st century nearly behind us, it's easy to dismiss the Triple Revolution as a mix of Cold War paranoia and unbridled optimism. Automation hasn't given us luxury communism, after all. But maybe their analysis wasn't entirely wrong. Maybe the revolution happened—just not the way they imagined. Instead of solving the problem, we've created something worse: a world dominated by bullshit jobs.

If you want "full employment," here's a foolproof plan: take every unemployed person, split them into two groups, hand Group A some shovels to dig holes, and then have Group B fill them back in. Voilà! Everyone's working! Except... they're not doing anything useful. It's tedious, pointless make-work that benefits precisely no one. The sad truth is that much of our modern economy operates on a slightly more polished version of this principle. Sure, we're not literally digging and refilling holes, but we're shuffling endless reams of paper, enforcing convoluted rules, and keeping armies of compliance officers, consultants, and middle managers busy. None of this produces anything tangible. It doesn't make us safer, happier, or more prosperous. It just keeps the wheels of bureaucracy spinning and ensures that enough people stay too busy to notice how much of their "work" is pure theatre.

Corporate offices are bloated with managers who "synergise" and "strategise" but couldn't pour water out of a boot if the instructions were printed on the heel. Government agencies churn out regulations that exist primarily to justify their own existence. If we narrow our definition of employment to only include jobs that produce a good or service someone actually wants to pay for, we'd quickly discover that a disturbingly large percentage of our population is effectively unemployed. These are people paid to generate nothing more than the illusion of productivity. Yes, the irony of this statement coming from a snarky premium Substack writer isn't lost on me.

Now, let's talk about technology. If advancements in automation and efficiency are driving productivity to the point where there simply aren't enough "real" jobs for everyone, what's left? Enter the Star Trek model. As Rick Webb suggests in his analysis, the Federation may function on a kind of universal basic income (UBI) tied to an energy-based economy. Imagine every citizen receiving an energy ration deposit that effectively allows them to live comfortably without working, like a welfare system that's scaled up to absurdly generous levels. Webb asks us to envision a society so efficient and wealthy that it could afford to give every man, woman, and child the equivalent of $10 million in today's dollars annually. That's not a bad starting point for imagining the Federation's economic structure.

But here's the kicker: the Federation does use money—just not in a way that most of us would recognize. Transactions are tokenized representations of energy credits. The key difference is that the average citizen's basic allowance far exceeds their typical needs. It's like being so

absurdly wealthy that you go to a five-star restaurant, order anything you want, and don't even blink when the bill arrives. You wave a card, the steak arrives, and you don't think twice about it. In the Federation, replicators have made this process almost magical, but the principle is the same: the mechanisms of exchange are background noise to the consumer.

Proponents of UBI argue that such a system could do more than just end poverty—it could free people to pursue work they actually care about. Sure, we'd still have doctors and engineers, but we'd also have a glut of mediocre artists and wannabe poets. Opponents, however, love to wring their hands over the supposed existential crisis this would unleash. "What about the meaning of work?" they cry. Without jobs to define us, wouldn't we all descend into nihilism and despair? Funny how these arguments always come from professors, think-tank wonks, and other members of the intellectual elite—people whose jobs are inherently interesting and rewarding. I've yet to hear a cashier or delivery driver wax poetic about how their soul is nourished by ringing up groceries or schlepping Amazon packages.

Of course, there's a kernel of truth to the opposition's point. For many working-class men especially, unemployment carries a deep sense of shame—not because the job itself is fulfilling, but because society equates employment with responsibility, usefulness, and the ability to provide for one's family. Unfortunately, that social contract is crumbling. More and more people are following all the rules, grinding away at their jobs, and still can't afford to buy a home or raise a family. And yes, some people probably would just sit around all day smoking weed and binging Star Trek if handed a basic income. But in a world where so much work is already make-work, administrative bloat, or outright harmful, we should ask: is that really worse?

Think of the most useless or destructive organization you can imagine—maybe it's the ATF, maybe it's CoreCivic, the private prison conglomerate, or some other monstrosity on your personal shit list. Wouldn't it be better to pay the people running these institutions to do nothing than to let them actively make things worse? That, in essence, is what the Federation seems to have done: paid people not to cause harm.

Now, let's briefly touch on the social dynamics of a system like this. Consider the 2006 documentary Do Communists Have Better Sex?, which compared East and West German couples. One takeaway—though not explicitly stated—was this: in capitalist West Germany, men could

compensate for their lack of personality or charm by being rich providers, as women were by and large expected to be home-makers. In communist East Germany, where wealth wasn't a factor and women were equally represented in the workforce, men had to be interesting to attract partners. If the Federation operates on similar principles, we might see a society where personality, intellect, and creativity outweigh material wealth as markers of social value. Anyway, back to the main thesis.

Handing everyone $10 million a year isn't going to turn Earth into a Star Trek utopia. It'll turn it into the same chaotic mess we've got now, but with the added thrill of skyrocketing inflation and price tags that make your eyes water. The fundamental problem isn't just throwing money at people —it's that we don't live in a world where wealth exists independently of the systems that produce it. You can't slap a Band-Aid on a broken system and call it progress.

But on a more foundational level, Star Trek doesn't run on cash so much as it runs on abundance. Over the past 200 years, we've seen steady increases in productivity, which have driven down the cost of goods and made life more comfortable for many (but not all—let's not kid ourselves). Star Trek takes that trend to its extreme: manufacturing becomes so trivial and energy so cheap that nobody spends their pay-check before the next one comes in—unless, of course, they're trying to pull a fast one and buy a starship. (Which, for the record, I would absolutely do. Who wouldn't want to cruise around the galaxy in their own Enterprise knock-off?)

But the Voyager scenario shows what happens when the Federation's fantasy of infinite abundance gets pinched: energy runs low, needs and wants suddenly collide, and people have to start making tough decisions about allocation. The invisible machinery of commerce rears its head, and boom—welcome back to the grind.

This brings us to the Federation's so-called "money." It's not like they don't have a system; it's just so far in the background that it might as well be magic. The Federation runs on what you could call an energy-backed, non-physical currency, coupled with an extremely high level of universal basic income. When resources are abundant, nobody thinks about FedCreds. But when scarcity hits, the system suddenly gets very relevant.

And what exactly is this Federation credit? Rick Webb suggests it might be a private currency, useful for trade with outsiders. Sure, plausible. But

I'd go a step further: it's more like a unit of account—something the Federation uses to price out its massive infrastructure projects (e.g., starships) and handle external trade. The only people who deal with it are bureaucrats and Starfleet quartermasters, while the rest of society blissfully ignores it. When life is cushy, money becomes something only the nerds have to worry about.

But let's get practical: replicators aren't on the horizon. 3D printers and CNC machines are cool, but they're not about to dismantle global supply chains or make energy and materials free. Fusion? Still the butt of every physicist's "just a few more decades" joke. Every form of large-scale energy production we know about requires infrastructure—stuff that has to be built, maintained, and eventually replaced. So, no, the average citizen isn't hitting post-scarcity levels of wealth anytime soon.

Still, we might be able to approximate a Star Trek-adjacent economy—call it "Star Trek at home."

Here's the deal: a future like this hinges on two things—production and finance. On the production side, we can expect technology to continue its slow crawl forward. Additive manufacturing will get better, automation will expand, and AI will handle more boring administrative tasks. But nothing short of a replicator is going to fully overturn agriculture, manufacturing, or logistics. What we'll get instead is rising productivity and a shrinking need for most kinds of human labour.

And then there's the financial system, currently optimized to shovel wealth toward the already-wealthy. Take the stimulus packages from a few years back: new money gets funnelled to banks and investors, who scoop up assets before inflation trickles down to regular people. The result? A stealthy transfer of wealth from the working class to the asset-owning elite. Cute trick.

So how do we rethink this? One option is a digital currency tied directly to economic activity. Think Bitcoin, but without the libertarian baggage or the environmental horror show. In this setup, currency could be created through decentralized, energy-efficient blockchain systems, with a twist: instead of miners hoarding all the rewards, the proceeds are distributed across the entire population. Every transaction feeds into a pool, and everyone gets a slice. No government middleman. No banks. Just a trickle of income that goes straight to the people.

But that's just part of it. Look at something like Alaska's oil dividend—a public fund that pays every citizen a share of the state's oil revenue. Now, expand that idea: revenues from public resources like energy production,

timber, and minerals go into a collective pot, fuelling the universal basic income pool. This model preserves enough profit to keep industries alive while ensuring the public gets a cut of the natural wealth.

Of course, this only works if we scrap the bloated welfare systems, tax codes, and enforcement mechanisms we currently have. A UBI can't just be another layer of bureaucracy; it has to replace the existing patchwork of entitlements and subsidies, making it a cost-neutral tradeoff.

Would this system make everyone rich? No. But it could ensure nobody is dirt poor—unless they make really bad life choices. It wouldn't create Star Trek-level wealth, but it would lay the groundwork for a society where people don't live pay-check to pay-check. Importantly, since the currency is tied to real economic activity (not government whims), it wouldn't unleash runaway inflation. Every unit of currency is backed by something tangible—goods produced, energy extracted, value created.

Now, does this solve everything? Hell no. For one, tying incomes to economic growth introduces vulnerabilities. If the economy shrinks—like Voyager's replicator rations—everyone feels the pinch. But let's be honest: that's not unique to this system. Our current economies implode under the same circumstances; this one would just make the stakes a bit more obvious.

The big win here is breaking free from the exploitative grind of late-stage capitalism without falling into the bureaucratic black hole of state-run communism. It's not utopia, but it's not dystopia either. It's something in-between, with enough structure to avoid chaos but enough freedom to avoid stagnation.

So, is it workable? Maybe. Maybe not. As Admiral Kirk said, "It had the virtue of never having been tried." And for the record, no, this doesn't mean I've gone full Marxist. I just think we can do better than capitalism's infinite rat race or the bloated failures of state-run collectivism. Somewhere out there, between the grind and the gulag, there's a system worth striving for.

125

The Lie of the Ideal Woman

Or How the Mainstream lied to generations.

The Lie of the Ideal Woman
Or How the Mainstream lied to generations.

A post on 4Chan, of all places—yes, that dank corner of the internet where critical thought sometimes crawls out of the primordial ooze to blink at the sun—has been making the rounds as a meme. And while it's tempting to dismiss any sentiment originating from the slurrypit of anonymity, this particular screed pierces deep into the festering heart of a societal malaise, one that exposes the rotted core of modern relationships. Here we stand, teetering on the precipice of the last year of the first quarter of the 21st century, still choking on the vapors of decades-old conditioning that have led us into a toxic wasteland of broken connections, misplaced ideals, and unchecked delusions.

I present the post here in its unfiltered form—raw, rancid, and absolutely necessary to examine—for this unpolished pearl deserves preservation, if only to illustrate how far we've let the sludge seep into our collective psyche.

You see, I'll be the first to admit that I, like many others, wasted far too much of my life chasing after an illusion—an archetype meticulously packaged and sold to me by the cultural propaganda machine of the late 20th century. The myth of the strong, independent, yet emotionally vulnerable woman. The "dream girl" constructed not to empower women, but to ensnare men, setting both sexes on a collision course with disillusionment.

Now, in this current iteration of late-stage feminism—an ideology so deranged that it drapes makeup and a sundress on a man, screeches "same thing!", and expects us all to nod in unison—it's almost quaint to remember that once, not so long ago, the media's portrayal of women was subtly destructive rather than cartoonishly dystopian. Back then, women were depicted as strong, capable, "equals" of their male counterparts—but crucially, they were sold to men as romantic rewards.

This was the archetype imprinted on young, impressionable minds like mine. This was the bait-and-switch blueprint: a woman who could challenge you, inspire you, and yet, beneath her rebellious veneer, was aching for you—the good man, the hero, the provider—to sweep her off

her feet and make her whole. It's the ultimate false promise. She gets to be both the sovereign ruler of her own destiny and the soft, devoted companion at your side. Men were programmed to believe in this woman. Women were programmed to aspire to be her. The whole thing, I now realise, was an absolute farce—one that birthed entire generations of disappointment, resentment, and emotional chaos.

Let's talk specifics, because nothing dismantles a lie better than holding up the pieces of its fabrication.

First, there's Ariel—the redheaded harbinger of every disillusioned millennial boy's first false ideal. Disney's "The Little Mermaid" (1989) doesn't just offer up a rebellious girl defying her father (the literal patriarchy, for those keeping score), it reinforces the notion that her recklessness—her self-destructive, shortsighted quest for romantic fulfillment—is heroic. She trades her voice (symbolising wisdom, agency, and her very identity) for the chance to chase a man she's barely met. And in the sanitized Disney version, it all works out! Cue the happily-ever-after and a generation of young girls quietly absorbing the lesson: recklessly pursue your fantasy, consequences be damned.

Of course, the boys watching Ariel weren't just seeing a fish-tailed ingenue. They were internalising her as the model. The kind of girl who defies rules, flouts authority, and yet—crucially—would still look at you with wide-eyed devotion if you proved yourself worthy. For a prepubescent boy, Ariel wasn't just a crush; she was a prophecy.

But Ariel was only the beginning. Enter the ultimate "badass-with-a-heart" archetypes: Sarah Connor and Ellen Ripley. These women, forged in the fires of sci-fi horror, brought the girlboss ideal to its peak. They were strong, competent, and fiercely protective of what mattered to them—but their stories also whispered something insidious to impressionable young men: "Look, you can have it all. The woman who doesn't need anyone—but wants you anyway."

Sarah Connor evolves from hapless waitress to warrior-mother. Ellen Ripley goes from pragmatic officer to maternal avenger. Both were sold as aspirational figures: women who could slay aliens, conquer apocalypses, and yet still embody a kind of feminine devotion to the ones

they cared for. But here's the catch—this fantasy asks something impossible of real women: to embody both masculine independence and feminine grace simultaneously. For men, it set an equally impossible standard: be worthy enough to melt the armor of a woman who doesn't need you.

And then, of course, there's the "quirky misfit" archetype—the Emmis and Stephanies of 80s cinema. Emmi, the mannequin-turned-love-interest, is literally crafted to be perfect for the man who idolises her. Stephanie, in "Short Circuit," crusades for a sentient robot's right to exist because her loneliness and emotional vulnerability leave her primed to cling to any cause that feels like purpose. Both characters drip with manic-pixie-dream-girl energy: attractive precisely because they're damaged, odd, and inexplicably fixated on the male protagonist.

These archetypes conditioned men to believe that love is a rescue mission. That the right woman—whether she's an ass-kicking Sarah Connor, a rebellious Ariel, or a wide-eyed misfit—would see you as the missing piece of her life, even if she didn't need you for survival. Women, meanwhile, were conditioned to believe that chasing impulsive dreams, defying logic, and leaning into emotional vulnerability would eventually lead to their Prince Eric, their Jonathan Switcher, or—if they played it cool —the strong, stoic hero who would finally "get" them.

Fast forward a few decades and we now inhabit the toxic wasteland left in the wake of this propaganda. Today's women are still clawing after empowerment, self-actualisation, and freedom, while the men who were promised strong-but-loving partners look around and see nothing but disillusionment. The cultural machine—now thoroughly hijacked by corporate feminism and nihilistic HBO smut—spits out hollow echoes of these old archetypes, rebranded for a new generation that doesn't even pretend to care about lasting connections.

And so here we are: men who are checking out, refusing to play a rigged game, and women chasing after fantasies with all the emotional foresight of Ariel signing away her soul to Ursula. The fallout is simple and devastating. Relationships are transactional. Vulnerability is exploitation. Love has become a dead language that neither sex can fluently speak anymore.

We've been sold a lifestyle that has left us emptier than ever. If this were just a tale of youthful delusion, it would be forgivable. But no—this fantasy was engineered. A deliberate narrative, crafted and sold over decades, until we all mistook it for reality.

And here we stand now—disillusioned, divided, and desperately clinging to echoes of an ideal that was never real to begin with.

:ontent.com/pod-product-compliance
nt Group UK Ltd.
1 Keynes, MK11 3LW, UK
260125
)0006B/351